the joy of
acrylic
painting

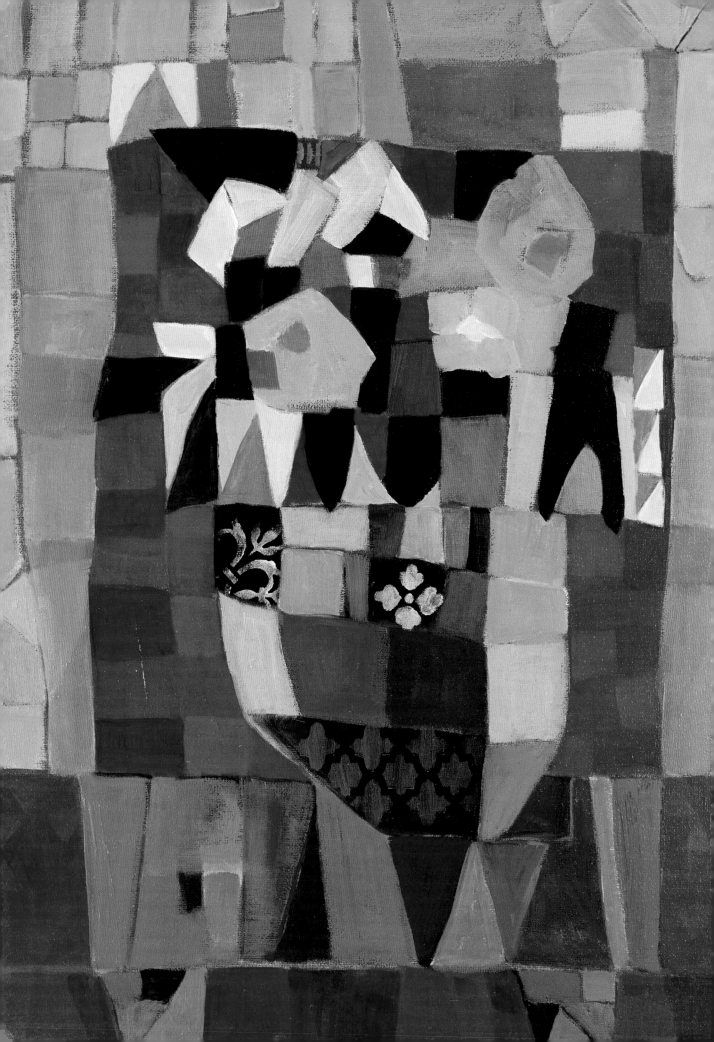

the joy of acrylic painting

Expressive
Painting
Techniques
for Beginners

ANNIE O'BRIEN GONZALES

NORTH LIGHT BOOKS
CINCINNATI, OHIO
artistsnetwork.com

contents

Incorporating Mixed Media 68

Expressive Painting Projects 84

Fixing and Finishing Your Work 122

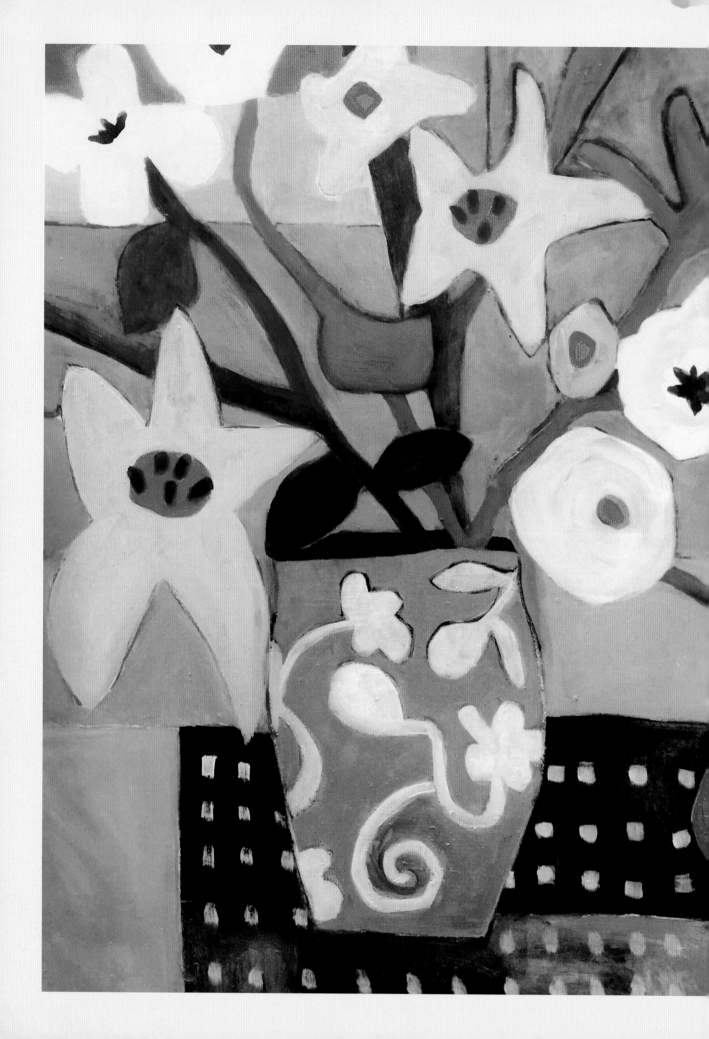

it's never too late to paint

THIS BOOK IS FOR people who have discovered their desire to paint or who set it aside because of competing life priorities and are now ready. My personal story reflects what many people have experienced. When I was about eight, I sent off a drawing to the Famous Artists School after seeing an ad for a "talent test" in the back of a comic book—"You are in demand if you can draw!" When I got an acceptance letter back, I was overjoyed! Of course, correspondence art school never happened because I was only eight years old and my family didn't have the resources for art lessons.

Fast forward thirty years—I had completed my education, raised children and had a "real job" while doing lots of arts and crafts on the side. At one point I went to art school but life interfered and I went back to the workforce. Twelve years ago, I decided to pursue my dream and took the leap to finally become a full-time artist. I had many doubts, but I decided it was now or never. I took painting classes, attended workshops, read lots of books on painting and painted almost every day. I have tried to remember what Georgia O'Keeffe said:

"I've been absolutely terrified every moment of my life and I've never let it keep me from doing a single thing that I wanted to do."

I have never looked back. I kept going forward until I discovered my style and clarified my artistic goals. I have learned a lot about learning to paint—what works and what doesn't—and I want to share what I have learned. For many years I taught adults in professional fields, but it wasn't until I started teaching painting that I ran into adults with so many doubts and insecurities about learning. For most adults, going to art school is not an option, nor would it be the right option unless the goal is to teach art at the college level. Fortunately, there are so many opportunities to learn to paint. The trick is finding what works for you.

I hope this book will serve as a practical resource as you start or restart painting. I know it won't meet everyone's needs. I paint in an expressive style—not realistic by any means. If you want to learn to paint pears that look as if you could pluck them off the canvas, there are other books and workshops out there to teach you to paint realistically. But if you are attracted to painting with color, pattern and texture as your subject matter, the lessons in this book might give you a jump start on learning to paint expressively.

I've heard lots of variations on my story—people who have always wanted to paint but are worried that it's too late for them or who believe that they are not blessed with the talent to paint. I intend to convince you that it's not about being anointed with talent from birth and that it's never too late to learn to paint. I have experienced successes on my journey to learn to paint, but I've also made some mistakes and a few wrong turns. I hope to share some ideas that might speed up your learning and help you avoid some pitfalls.

◄ **THESE LITTLE THINGS**
Acrylic on canvas
24" × 24" (61cm × 61cm)

materials

This list includes basic materials needed to begin expressive acrylic painting. You will see that I have chosen several personal favorite paint colors for some projects. You will probably want to add your own special colors beyond the basics listed here as you begin to paint more.

Feel free to substitute what you have available in your studio and buy only what you need in small quantities to begin. Many items can be found in your household as well.

- **Acrylic Paints**
 Heavy body, professional grade
 One warm of each primary color, one cool of each primary color and one of each secondary color plus a tube of Ivory Black and a larger tube of Titanium White.

 Suggested primary colors: Cadmium Yellow Medium, Cadmium Yellow Light, Ultramarine Blue, Phthalo Blue (Green Shade), Cadmium Red Medium, Quinacridone Magenta.

 Suggested secondary colors: Cadmium Orange, Phthalo Green (Blue Shade), Permanent Violet Dark.

 Fluid, a few basic colors
 Suggested fluid acrylic colors: Nickel Azo Yellow, Phthalo Turquoise, Quinacridone Magenta.

 * A few projects include fluorescent and iridescent fluid acrylic paints. Feel free to decide to purchase your own favorite colors.

- **Acrylic Painting Mediums:** Acrylic glazing liquid or matte medium for painting and matte medium for collage
- **Apron or Painting Shirt**
- **Canvases and/or Panels:** Gessobord or inexpensive canvas panels—see specific projects and techniques for recommended sizes.
- **Collage Paper:** A variety is good.
- **Color Wheel**
- **Pencils:** colored and drawing
- **Cork Bulletin Board and Pushpins**
- **Easel** (or flat surface to paint on)
- **GelliArts.com Gelli Printing Plate**
- **Markers**
- **Other Mediums:** self-leveling gel (Golden), polymer varnish with UVLS or satin varnish, cold wax medium (Gamblin)
- **Paintbrushes:** Inexpensive synthetic or bristle brushes, ¼", ½", 1", (6mm, 13mm, 25mm) bright or flat shape and one small round brush
- **Paper Palette Sheets:** Or a roll of parchment paper will work
- **Permanent Writing Pens:** I like Marvy LePens and Pigma Microns because they don't bleed through paper.
- **Rags or Paper Towels**
- **Ruler**

- Scissors
- *Scraping and Mark-Making Tools:* A bowl scraper, plastic key card, squeegee or similar
- *Soft Pastels:* A few in favorite colors
- *Soft Rubber Brayer:* 2"–4" (5cm–10cm)
- *Spiral Sketchbook:* 8½" × 11" (22cm × 28cm)
- *Spray Bottle for Water*
- *Stencils:* Hand-cut or purchased
- *Tape*
- *Tracing Paper*
- *Water Container*
- *Water-Soluble Crayons*
- *Watercolor Paper, Mat Board or Bristol Board*

becoming an expressive artist

You can't use up creativity. The more you use, the more you have.

—MAYA ANGELOU

This first chapter explores the skills you bring with you and those you will need to cultivate to become an expressive painter. Here, I'll help you assess both, as well as help you determine the best means of setting goals for yourself.

As a means of keeping track of all of the above, our first task is to create a space for documenting your journey, and I'll share with you how to set up what I call your Painting Notes.

With a place to organize what you learn and record what inspires you, you'll be ready to try out your first painting. We have a lot to explore, so let's begin!

◀ **ALAMEDA GARDEN**
Acrylic on canvas
24" × 24" (61cm × 61cm)

project 1: Set Up Your Painting Notes Sketchbook

Before I can help you assess the skills you already bring to painting, the skills you'll want to develop, the best way to set goals and the more effective methods of curating inspiration, you're going to need one go-to place to keep track of all the above. The method that has worked for me is to train myself to keep track of everything in what I call my Painting Notes. Painting Notes are more than just a sketchbook and different from a journal. Your Painting Notes should be the place where you diligently record inspirations, ideas, plans and samples to create a personal library of ideas.

It is a working tool that you will find invaluable. Don't get hung up on making your Painting Notes beautiful—this book is for content and ideas. Don't dissipate creative energy by turning your Painting Notes into a journal—save that creative energy for actual painting.

Get in the habit of putting your ideas/samples/sketches in one place—your Painting Notes—as soon as they come to you. When you fill Painting Notes volume one, start on volume two. It's a great place to keep a record of ideas—names for paintings or painting series for example—things that are easily forgotten if you don't write it down. Carry your Painting Notes with you to your studio, to workshops,

on trips to galleries and museums, just about everywhere. Be sure to date your entries and the volume. It's interesting to go back and track your projects and interests over time. Renowned British artist David Hockney even had his suit pockets altered so his books would fit. Take it with you everywhere.

what you need

- coloring implements (colored pencils, markers, etc.)
- inspiration (magazine clippings, photos of meaningful objects, pleasing design elements)
- pens (I like Pigma Micron pens or LePen)
- scissors
- sketchbook, large spiral, 9½" × 11" (24cm × 28cm) minimum
- tape (double-sided or scrapbook adhesive tape)

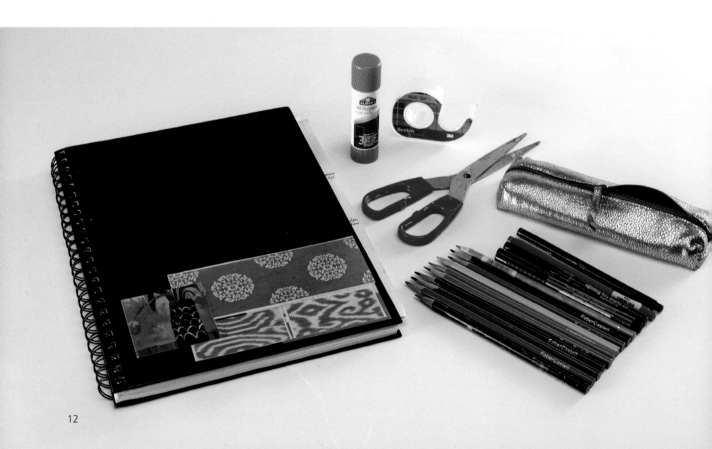

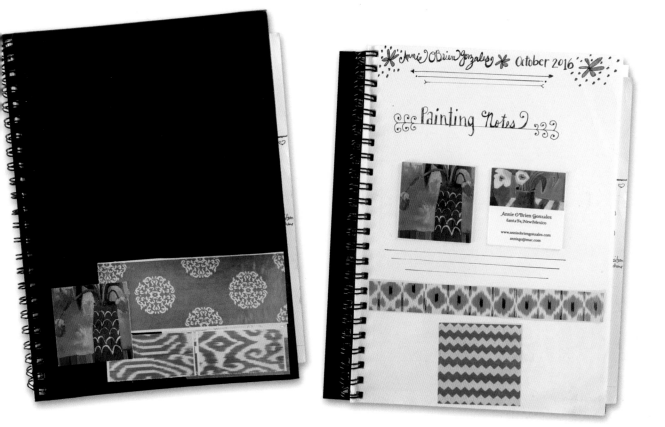

I Find a sizable spiral sketchbook and label it Painting Notes, Volume One and date it somewhere. It should be large enough to really spread your ideas and notes across the page but still fit in your tote bag. Spiral-bound is important so you can comfortably work in it and use it as a reference. Make sure it's not too expensive—no leather-bound embossed journals for this project. You want a large, working sketchbook that will be up to the task. Don't think too hard on getting just the right book.

quick tip

There's a big difference between an art journal and what I call Painting Notes. You will see lots of books and websites about art journaling. That is *not* what this is meant to be. Painting Notes serve as a working reference stuffed with ideas for paintings. Many art journals are meant to be works of art in themselves. Painting Notes don't have to look pretty; they need to serve as your guide along the art path. If you have to stop and think about composition, color, etc. before you create an entry in your Painting Notes, it will be too much trouble and will defeat the purpose.

ideas for painting notes

I advise starting a new page for each category of ideas so when the inspiration hits, you will have plenty of room to jot whatever down.

- Your thoughts on the techniques and projects in this book
- Notes from workshops or lectures, trips to museums, galleries
- References you want to track down
- Ongoing list of painting titles
- Ideas for painting series
- Favorite song fragments or lines in poems
- Fragments of conversations or advertising slogans
- Catalogs of shapes, patterns and personal symbols
- Photos of color combinations from magazines
- References you find inspiring
- Subjects, themes, things, places, songs, books that grab you
- Photos, scraps of paper, quotes

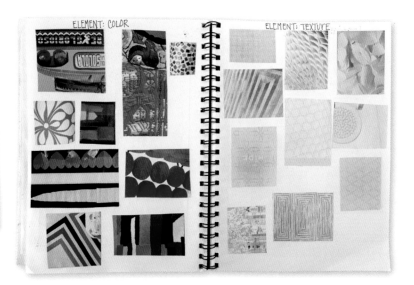

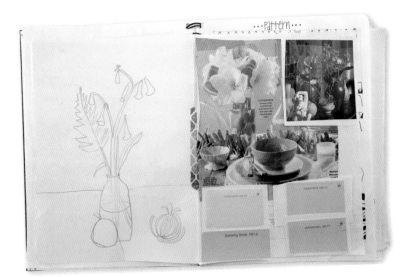

2 Start an entry with the date and a few notes quickly jotted down about your entry.

3 Tape in photos, magazine clippings, brochures, maps, whatever sets your ideas in motion.

4 Add small quickly done sketches with colored pencils, markers or pens to remind yourself of what you might create with this idea.

5 Create pages for shapes, symbols, objects, elements, materials, patterns and colors that attract or inspire you.

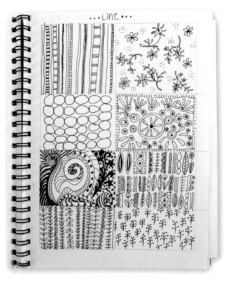

quick tip

Take your Painting Notes with you everywhere and make it a habit to record all the great ideas you run across. Here are a few ideas to get you started thinking of personal symbols: colors, circles, totems, animals, seedpods, stripes, patterns, spirals, microscopic forms, polka dots, pink things, flowers, hearts, birds, letters, spheres, raindrops, eggs, shells, fabric patterns, wallpaper.

It will become your most valuable resource for inspiration and will come in handy when the well of ideas has run dry.

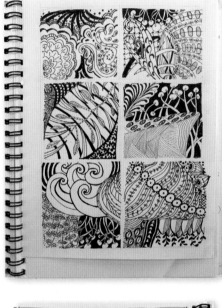

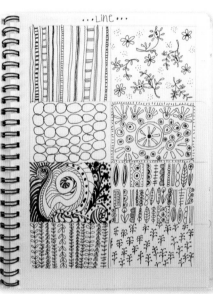

6 Write a little something each day, doodle, describe elements such as line, shape or pattern, stick a photo or clipping in your Painting Notes or sketch something quickly.

7 Add your notes from workshops or lectures on painting, trips to museums, galleries, references you want to track down or even ideas for what to title paintings.

8 Record your approaches to the techniques and projects in this book, along with notes about what worked and what didn't.

Skills You Bring and Skills to Develop

Skills You Bring

If you are just getting started with painting or you are restarting after a prolonged absence, it's useful to take a look at all the skills you already possess and recognize the strengths you bring with you. In your Painting Notes, reflect on where you have been and what you already know. Here are a few prompts to get you started thinking:

- Write down all of the ways you are already creative—cooking, decorating, gardening, school projects with kids. Think through everything you do and acknowledge your own creativity.
- List creative courses/projects you may have participated in at times in the past.
- Make lists of your favorite museums/galleries/cultural events and how you have kept the spark alive.

Skills to Develop

It's time now to really take a look at what will be required to learn to paint well. Painting well requires three areas to stretch and develop: your "Heart, Hand and Eye," which translates to your "Passion, Skill and Vision." (In *Bold, Expressive Painting: Painting Techniques for Still Lifes, Florals and Landscapes in Mixed Media* [2016], I explain how I first came across these ideas, made popular by David Hockney.) Each person's learning curve will be different and will develop at different speeds. First, analyze where you are now on the painting learning curve in each of these areas.

1. Heart (Passion)-The desire needed to prioritize learning to paint. Without a passion for painting, the work will not sing; it can be very proficient and competent but lack passion. You may also find it difficult to allot the time to paint.
2. Hand (Skill)-Specific definable skills and knowledge needed to paint.
3. Eye (Vision)-A unique idea about what and how to paint that expresses your individual painting style. This usually develops later in the process.

Once you have decided where you are on this learning curve, be selective about where you spend your precious energy and hard-earned money. You do not need to go to art school or pursue a master's degree in art unless you want to teach at the college level. If you just want to learn to paint, fortunately there are many other opportunities available for adults to learn to paint.

My advice is to choose selectively from the many books, workshops and online classes that meet your needs. Analyze the specific skills you need and go for those in a style that most attracts you. Once I decided that since I loved flowers and would love to know how to paint them, I thought it would be a good idea to take a botanical drawing course. Total mistake. Realistic, detailed botanical drawing was not a fit for me. I misinterpreted my passion for flowers because I was unaware of other ways to paint. All I knew instinctively was that spending four hours learning to shade a dewdrop would never work for me. I had to step back and realize that what attracted me was the color, pattern and exuberance of flowers, not the anatomical details. I was in the wrong class. Don't be afraid to cut your losses when you start down a blind alley. There is no one who can tell you what fits for you. Don't waste any time trying to fit yourself into a style that doesn't work for you because you think it is more prestigious than other ways of working. If you keep following the breadcrumbs of what delights you, you will find your path.

If you really start to take apart the obstacles of what are stopping people from living a more creative life, it's almost always fear. It's very rarely not fear.

—ELIZABETH GILBERT, *BIG MAGIC*

area	assessment	remedy
HEART	Am I passionate enough to allot the time, energy and space to learn to paint?	• Decide what things I will give up in order to make time to paint (TV, Internet, gaming). • Create a schedule with a designated time for painting. • Be content with a slower learning curve knowing that at some point in the future I will have more time to devote to painting. • Pursue activities to enhance creativity: music, nature, travel, concerts, museums, galleries.
HAND	Which painting skills do I need more knowledge about? • Paint, mediums and other painting materials? • Color mixing? • Application techniques? • Composition? • Use of the Elements of Art: line, shape, color, value, texture? • Finishing techniques?	• Targeted workshops • Specific books on painting techniques • Online classes • Museums and galleries • Mentors • Feedback from other artists/collectors, critique group, reading about other artists
EYE	Do I have unique ideas for a series of paintings that demonstrate my personal style?	• Identify my unique inspirations and record them in Painting Notes. • View lots of work by other artists. • Diligently paint in a style I aspire to: watercolor, realist, impressionist, expressive, what kind of painter am I? • Move away from copying other artists' work or style. • Learn to critically critique my own work. • Find a seasoned mentor to give direct feedback on my work. • Take chances, enter shows, create a website and ask for feedback.

In Anne Lamott's wonderful book on writing (*Bird by Bird: Some Instructions on Writing and Life*, Anchor Books, NY, 1995), she tells the story of her brother trying to finish a daunting school report. Her father's wise advice to him was "Bird by bird, buddy. Just take it bird by bird."

There's no magic, no shortcut, just take it "bird by bird," step-by-step and you will get there. Now that you have done your self-assessment and figured out where you are on the continuum of learning to paint, you are ready to develop your Painting Development Plan. Create some doable short- and long-term goals for yourself and write them down in your Painting Notes. (See Project 1.) Make a list and check off each of your accomplishments. This is no fuzzy wish we are talking about here; this is doable, accountable learning taking place! Periodically revisit your plan and keep moving your goal a few steps forward—dream big! If you haven't yet, go pick up and read Elizabeth Gilbert's book *Big Magic*. It's real, and it's out there waiting for you.

Here is an example of a Painting Development Plan. Create a page in your Painting Notes sketchbook to write down your plan.

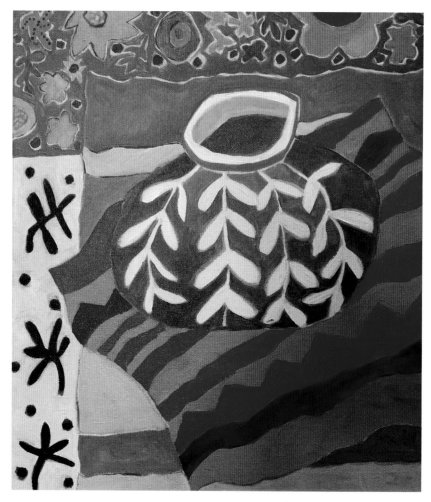

▲ **SANTA FE SUMMER**
Acrylic on canvas
16" × 20" (41cm × 51cm)

Following your passion sets into motion a creative cycle in which passion fuels your painting and your painting then refuels your passion.

—**DAKOTA MITCHELL**

Sample Painting Development Plan

need	Time	Space	Motivation
solution	Create a schedule for painting.	Find and set up a space in which to paint.	How could I reward myself?

need	Painting skills	Produce more work	Get work out into the world
solution	• Color mixing • Use of mixed-media materials • Paint, brush, tools handling • Acrylic techniques • Composition	• #paintings/month • Classes/workshops taken • Painting books studied • Projects done from this book	• Enter local art show • Create a web page for your work

need	Feedback	Learning opportunities	Inspiration
solution	• Join a critique group • Find a mentor	• Internet • Workshops • Classes • Websites • E-courses	• Museums • Galleries • Outdoor adventures • Talks

Find Inspiration

Inspiration is all around you. Start to notice what attracts you and record it as a reference for future paintings. The more you begin to notice the inspiration around you, the sharper you will get at recognizing it.

Open your awareness to your own history, talents, interests and fascinations that make you who you are. What activities bring you true joy—cooking, setting a beautiful table, dressing creatively, hiking, gardening, movies? There must be many things. These things tell you something about what inspires you and holds your interest. Make a point of stopping in museums and galleries when you are traveling; they are in many towns and you might be surprised by what a random visit triggers in you.

Some artists find inspiration externally and others internally; it's a personal frame of reference. Think about the direction you consistently look toward for inspiration:

- *External Focus:* You are inspired by what is around you—travel, people, nature.
- *Internal Focus:* You are inspired by your own heart and emotions.
- *Both!* Georgia O'Keeffe, for example, painted what she felt but was inspired by natural beauty.

Check out popular design magazines (home design, gardening, cooking, crafting, etc.) that contain brilliant color schemes and composition ideas created by some of the most talented designers. Start to look at them with artist's eyes.

Take note of display windows, nature, clothing, antiques, music, people in cafes, the sky There is no limit. The more you exercise your creativity, the more it will grow and show up for your art.

It's a good idea to collect your inspirations before they fly out of your mind. Three approaches I recommend include Pinterest, inspiration boards and Painting Notes.

Pinterest is a great way to tack inspirations you find on the Internet onto virtual inspiration boards that will be at your fingertips. Start by joining Pinterest online, if you haven't already, and create separate Pin Boards for your inspiration categories. If you are fascinated by birds, start a "Birds I Love" board, for example. Start Pin Boards for all of your Artist Ancestors, those artists who have inspired you. If you prefer not to share your interests publicly, you can always make your Pinterest boards private. You could also share your boards with a group you define so it's possible to form your own critique group online. The possibilities are endless on Pinterest. For ideas, check out my Pinterest Boards on the five Elements of Art. I have a board for each one: Line, Shape, Color, Value and Texture plus way too many other boards! Here's the link: pinterest.com/annieogo.

I have things in my head that are not like what anyone has taught me - shapes and ideas so near to me - so natural to my way of being and thinking that it hasn't occurred to me to put them down.

—GEORGIA O'KEEFFE

▶ **BREAKFAST**
Acrylic on canvas
12" × 9" (30cm × 23cm)

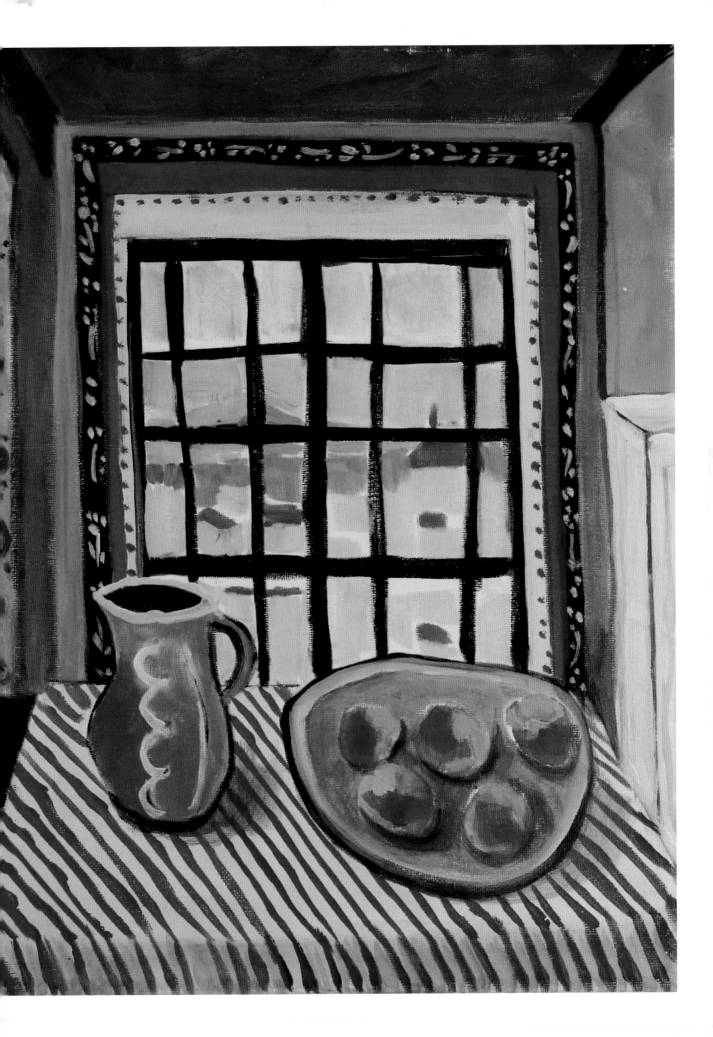

project 2: Make an Inspiration Board

As artists we respond to and actually require visual stimulation. Inspiration boards are visual references of what excites us at the moment. Create an inspiration board right away in your studio or painting area and pin on it anything that excites and delights you—color chips from the hardware store, swatches of fabric, photos, postcards, clippings from magazines, and quotes that inspire you to keep creating. But be careful not to put your to-do list on your inspiration board or you may decide you never want to look at it!

what you need

- cork bulletin board, largest size to fit your space
- inspiration (clippings, swatches, photos, quotes, etc.)
- pushpins

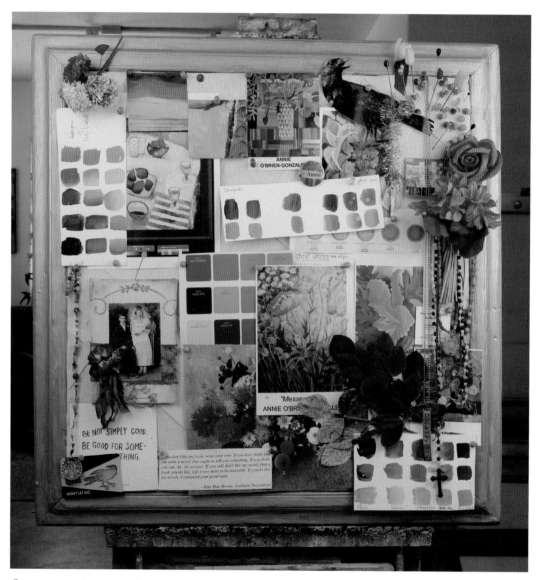

Hang your inspiration board in your studio or work area so you will see it every day.

strategies in case inspiration doesn't show up!

- Go to your studio or work space anyway. Don't talk yourself out of it. Show up and see what happens.

- Do busy work: wash brushes, gesso canvas, organize collage paper, clean your studio space.

- Grab an old painting and paint over it. Slap paint around in ways you've never done before like you have nothing to lose, which you don't!

- Sit in your work space and look through inspirational art books or magazines and put tags on anything that intrigues you.

- Take your Painting Notes sketchbook outside, sit and make lists: song titles, quotes you've overheard, flowers you love, favorite animals, etc.

- Fill the pages of your Painting Notes with doodles or just shapes or lines.

- Turn on your favorite music really loud in your studio, put a large blank canvas up, dance and throw paint on it.

- Pick one of your favorite Art Ancestors' paintings and copy it—it's good practice and quite an acceptable way to learn. Just don't sign it and show it as your own!

- Try a technique you've never done before, like collage with junk mail, cutting up old drawings or paintings, origami from art magazines. Just wing it!

2 Collect your inspirations and pin them on your inspiration board without thinking about editing—stay in your expressive, creative brain rather than your analytical brain.

project 3: Personalize a Painting

All artists are concerned with developing their own signature style. One way to create your own style is to paint what is personal to you. Rather than copying what is trendy or what you see other artists painting, why not make conscious choices about the icons and symbols you incorporate so that they become personal to you?

Artists have incorporated symbols as a form of communication since cave painting. Symbols can be shapes, colors, images, almost anything that is endowed with a meaning by human beings. We see symbols all around us and some resonate with us more than others. We put them on our cars, our T-shirts, our furnishings. We are communicating through symbols every day whether we realize it or not.

One of the best ways to personalize a painting is to begin to incorporate symbols that are meaningful to you. We all have shapes, motifs and objects that resonate with us. Take notice of symbols in your environment that you are drawn to, the choices you make every day. Do you constantly choose clothing with stripes or polka dots? Those are symbols for you. What about geometric shapes, labyrinths, arrows—do they show up in your doodles? Those are communication symbols for you. In this project you will select one or more of your personal symbols and create a small painting that is your personal statement about something you love.

what you need

- acrylic paint, high quality, colors that express your icons (I used Golden Fluid Acrylics)
- canvas or panel, small
- dry pastel, contrasting color to paint
- paintbrushes, synthetic or bristle, bright shape, ½", 1" (13mm, 25mm)
- Painting Notes
- palette sheet, disposable
- rags or paper towels
- scraper or plastic key card
- water container

1 Refer to your Painting Notes and choose your personal icon for a small painting.

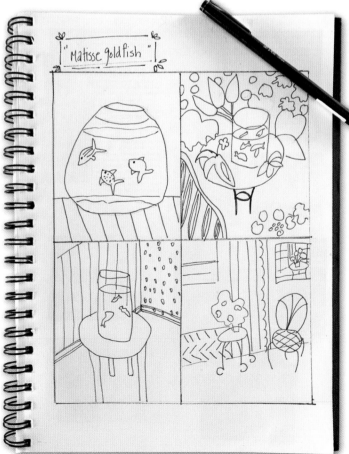

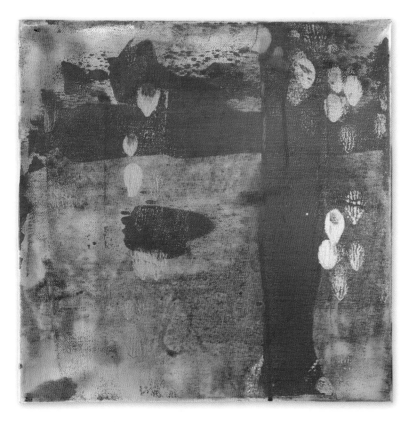

2 Create color scheme swatch. I recommend always deciding on a color scheme in advance and creating a small swatch as a reference. For this project, I chose a complementary color scheme of reds and greens. For more information on choosing a color scheme check out the three "Go-to" color schemes I recommend in Chapter 3.

Use a piece of mat board or watercolor paper for your color scheme swatches. You might label them on the back with the names of the paints you used. Save them as references for future paintings—soon you will have a library of color schemes!

3 Underpaint a canvas or panel with several colors of fluid acrylic paint, spreading loosely with a plastic card or bowl scraper. You can squeeze the paint directly on the canvas or panel and spread thinly.

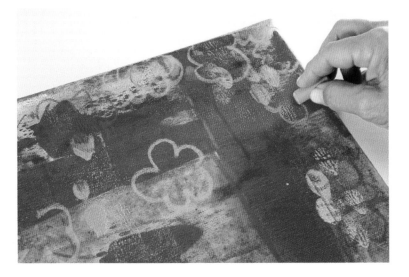

4 Draw a simple line drawing of your composition with a contrasting pastel.

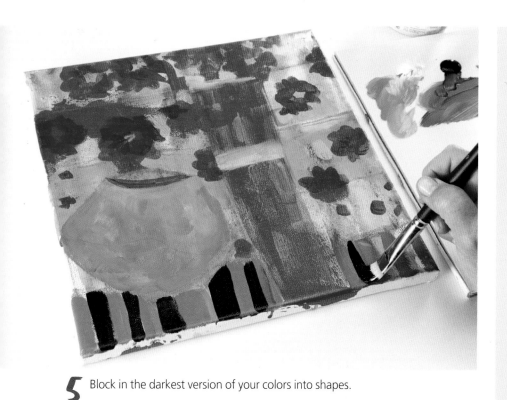

5 Block in the darkest version of your colors into shapes.

6 Add marks and more color. Add details as desired.

A few ideas to get you started thinking of personal icons and symbols:

- colors
- circles
- totems
- animals
- seedpods
- stripes
- patterns
- spirals
- microscopic forms
- polka dots
- pink things
- flowers
- hearts
- birds
- letters
- spheres
- raindrops
- eggs
- shells
- fabric patterns
- wallpaper

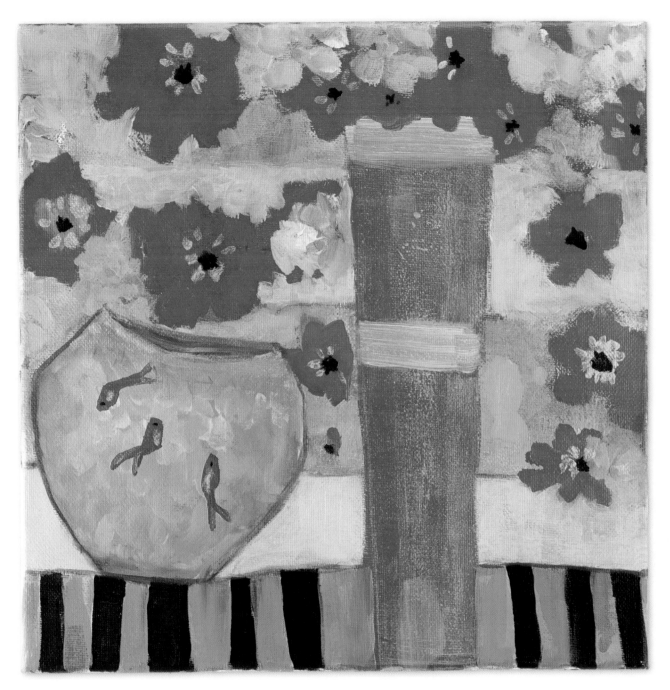

This little painting draws on the imagery of one of my Artist Ancestors, Henri Matisse, by including the goldfish, which have also become one of my favorite icons.

Learn From Artist Ancestors

Another source of inspiration is the work of artists who have stood the test of time. Every artist has individual tastes in artists they find inspirational. For example, the works of three very different artists—David Hockney, Henri Matisse and Georgia O'Keeffe—make my heart race for very different reasons. There are many others, even renowned artists, who leave me absolutely cold. I'm sure you are the same. Artists who resonate with us are what I call our Artist Ancestors and I believe it's useful in our development as artists to think about why. Most of us know intuitively which artists they are when we see their work. Pay attention to that signal so you can take the next step.

To learn from the work of an Artist Ancestor you love, apply the analytical part of your brain to analyze what it is that makes his or her work so appealing and whether you can apply that to your own work. When you combine elements from your Artist Ancestors with your own interpretation, you are creating your own painting style. All artists are an amalgam of inspiration from other artists and innovations of their own. Once you have analyzed the elements that you want to incorporate in your own work, you can move from imitation to innovation using those elements.

Study your Artist Ancestors, learn from them and take away ideas to incorporate into your work. How can you include some of their ideas in your own work? And what about copying? Is it a bad thing? It is a fact that all artists through time have learned from other artists. The trick is to take what you learn and make it your own.

In your Painting Notes sketchbook, brainstorm a list of three to five artists who consistently attract your attention—your Artist Ancestors. For each Artist Ancestor, create a full page in your Painting Notes with the artist's name at the top of the page and attach a reproduction of one of your favorite pieces of that artist's work. Study the work and jot down what you find most appealing about the work. Some questions to ask yourself might be:

How do you feel about the artist's use of the Elements of Art: line, shape, color, value, texture?

Is the subject matter something that would interest you?

Is there a unique composition you might employ?

Repeat this process for each artist on a new page in your Painting Notes. Collect all of the elements that bubbled up in your analysis of your Artist Ancestors onto one page and see which ones keep recurring and how you might try these ideas out in your own work. This will give you insight into your particular painting style and a direction for future work.

Everything is a remix, so steal like an artist.
—AUSTIN KLEON, *STEAL LIKE AN ARTIST*

▶ **HENRI'S WINDOW**
Acrylic on canvas
20" × 16" (51cm × 41cm)

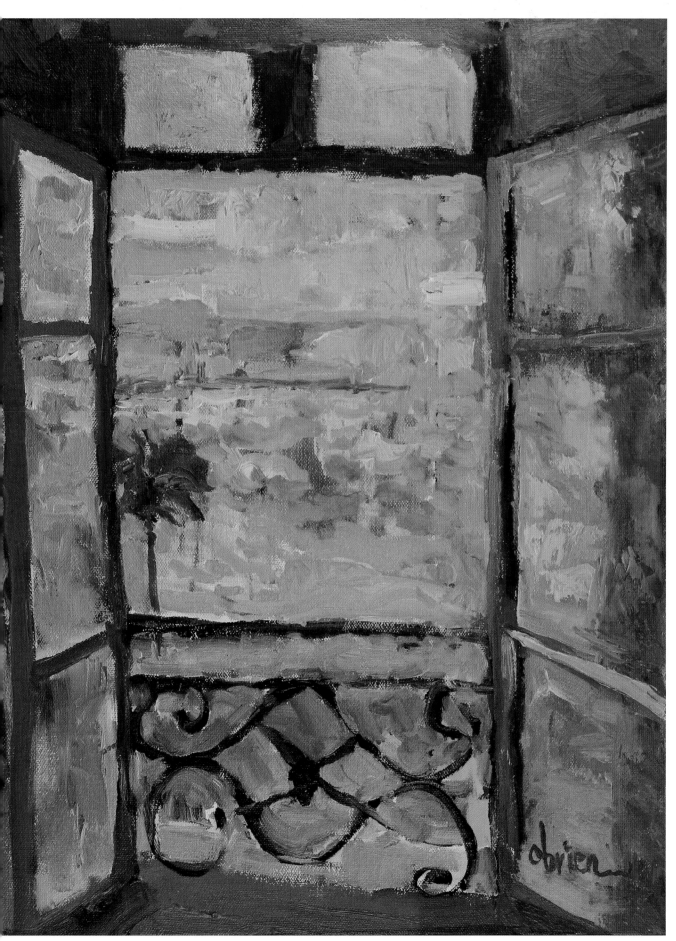

project 4: Paint as an Artist Ancestor

This project is designed to give you a chance to try out the techniques of your favorite artist in your own work. I painted this example in the style of Henri Matisse, a master expressionist painter. I love his work and gravitate to many of the elements including the warm colors and loose brushstrokes. For your project, choose a painting from one of your Artist Ancestors, define the elements of his or her work and then paint using that approach. You will learn a lot and will be able to consciously decide whether that approach will work for you. Analyze the style of the painting you are using as your inspiration and record your thoughts in your Painting Notes similar to my example for this project.

- *Line*: extensive use of black lines to outline and define objects as well as create lines of movement directing the eye to the focal point
- *Shape*: expressive nonrealistic shapes of objects; shapes continue off the picture plane (table, drapery, window); combination of organic and geometric shapes
- *Color*: expressive, nonrealistic colors; predominantly warm palette
- *Value*: use of strong dark/light contrast
- *Texture*: tactile texture; strong, vigorous, loose brushstrokes; visual texture through use of pattern
- *Other*: mood is overall cheerful

what you need

- acrylic paint, high quality, color palette of example painting
- canvas or panel, 11" × 14" (28cm × 36cm) or larger
- copy of a painting by an Artist Ancestor and notes about their style in Painting Notes
- paintbrushes, synthetic or bristle, bright shape, ¼", ½",1" (6mm, 13mm, 25mm), plus a small round

1 Select an Artist Ancestor who inspires you. What piece of work makes you swoon? I chose Henri Matisse's painting *Table with Fruit*.

Analyze the painting in your Painting Notes by assessing his or her use of the five Elements of Painting: line, shape, color, value and texture. Next review the Design Principles emphasized by that painter (*see list in the previous column) and how these play a part in their work.

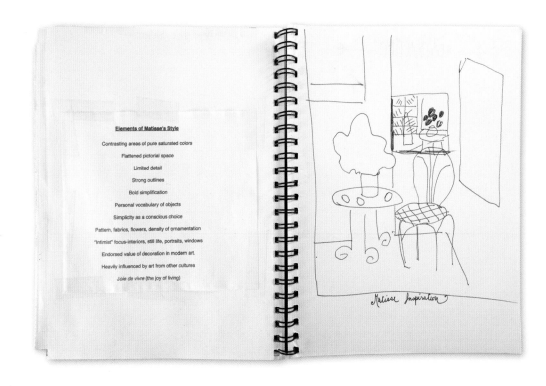

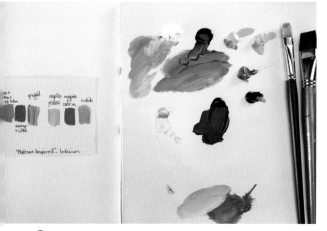

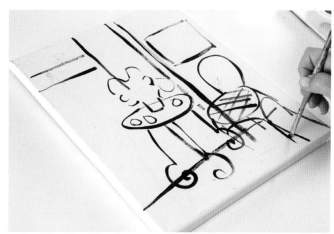

2 Create a color palette using the inspiration painting as a reference. Keep this reference close by.

3 You can decide to copy the composition of the inspiration painting or select your own subject matter to be painted in the color palette and style of your Artist Ancestor.

After studying Matisse's work, I sketched my composition onto the canvas without an underpainting because I had noticed he sometimes let the white canvas show in places.

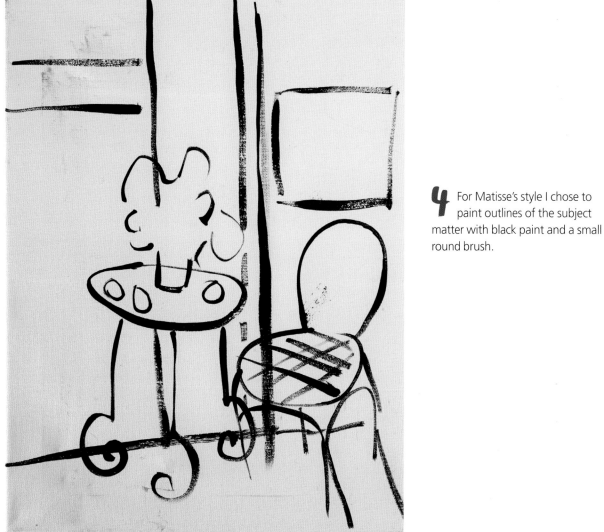

4 For Matisse's style I chose to paint outlines of the subject matter with black paint and a small round brush.

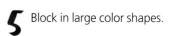

5 Block in large color shapes.

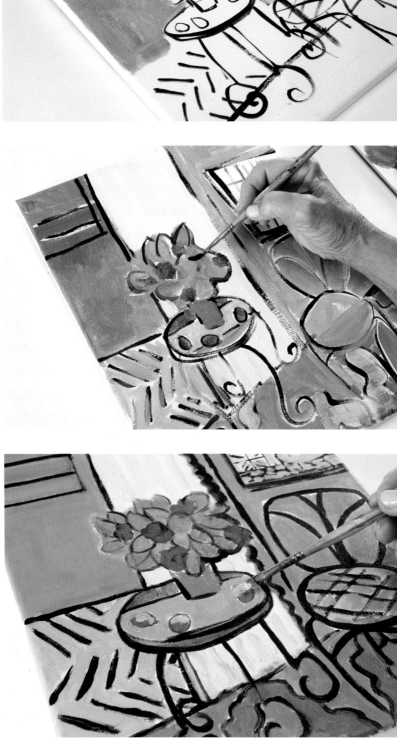

6 Add variations on color and thicker paint to describe the image.

7 Add smaller details to break up the large shapes using your Artist Ancestor's painting as a reference point.

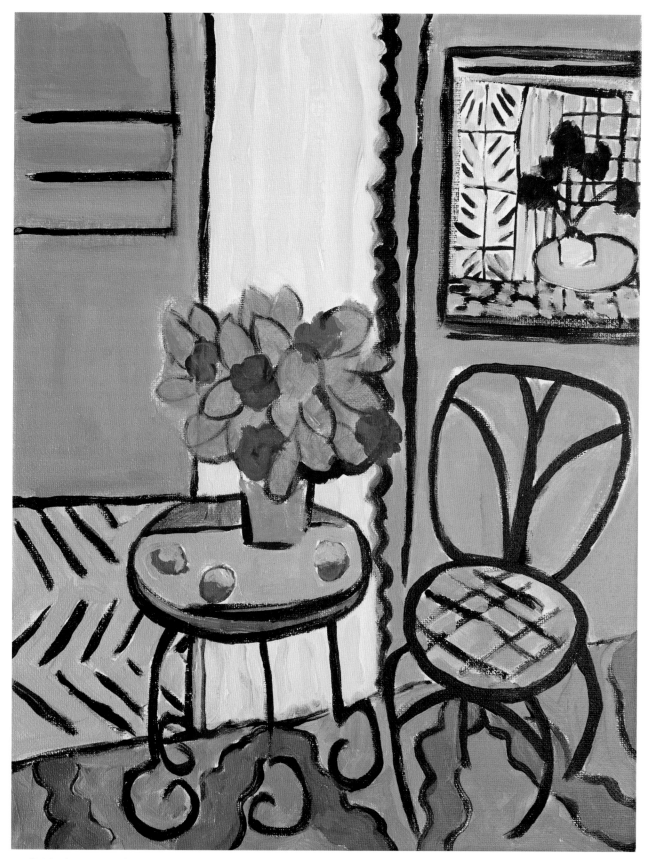

My finished painting reflects my study of the line quality and
color used by Matisse but I used my own imagery.

painting materials and techniques

Creativity itself doesn't care at all about results; the only thing it craves is the process. Learn to love the process and let whatever happens next happen, without fussing too much about it.

—ELIZABETH GILBERT

Learning basic painting techniques and creating a systematic approach is the foundation of learning to paint. Starting out with the right materials including high-quality paint will speed up your learning. This chapter is focused on materials and techniques for painting with acrylic paint and mixed media and will guide you to a solid foundation for learning to paint.

◀ **FINALLY SUMMER**
Acrylic on canvas
24" × 24" (61cm × 61cm)

Acrylic Paint and Mediums

Acrylic Paint

All of the exercises in this book are done with professional-grade acrylic paint. I recommend starting with acrylic paint if you are new to painting. Here are several reasons why acrylics open endless possibilities for creativity:

1. Because acrylic paint dries quickly and can easily be painted over again, it is very forgiving and great for new painters.
2. You can alter the texture of acrylic paint from thick, impasto, oil-like strokes to very thin, watercolor-like washes. A range of acrylic mediums allows you to achieve the desired results.
3. Acrylic paint works well with all types of mixed media: crayons, pencil, charcoal, collage, even objects since it can function as a tough water-resistant glue.
4. Cleaning up brushes used with acrylic paint is easy using water and a little mild soap. I prefer Murphy's soap but many people keep a bar of Ivory soap by the sink to clean their brushes. The important thing to remember is to clean brushes promptly and not to leave paint on a brush for too long since acrylic paint dries so quickly. Use a painting apron or wear old clothes, because acrylic paint is difficult to remove from fabric.

Always choose professional-grade, artist-quality acrylic paints for best results in your work. I can't stress this enough. Artist-quality acrylic paint contains more pigment and handles much better than student-grade. Trying to learn to paint with student-grade paint will slow your learning curve and leave you disappointed with your results. I have witnessed firsthand the frustration of students in workshops attempting to use student-grade with poor results. Because of the low pigment load and the amount of filler in student-grade paints, mixing colors cannot achieve optimum results and the richness of color just isn't there.

If money is a concern, you will learn much better by selecting fewer colors but richer professional-grade paint than purchasing a whole table of cheaper paints.

Painting Mediums

Acrylic painting mediums are color-free acrylic polymer substances ranging in thickness from watery fluids to thick gels and pastes, which give painters the flexibility to fine-tune paint consistency. Adding mediums changes the feel of the paint and greatly expands the possible options in the painting. Mediums can also affect the sheen of the painting surface and the thickness of brushstrokes, and can be used for adding collage elements or a glaze to paintings. For extensive information on mediums, go to the Golden Artist Colors, Inc. website (www.goldenpaints.com) for information.

Brushes and Other Mark-Making Tools

Mixed-media acrylic painting opens the door to a world of creative tools for making marks in acrylic paintings. Brushes, of course, are the primary tool utilized in painting. One misconception that many people have is that you need to spend a lot of money on brushes, but this is certainly not true in acrylic/mixed-media painting. You can get started in acrylic painting with just a few brushes and do quite well.

My advice is to start with a few basic brushes and add brushes as you find a need for them. I prefer the bright shaped brush, which is straight across the bristles but short in length. It is easy to handle and able to create a wide range of brushstrokes. You may want to try flat or filbert shaped brushes, which are also commonly used in acrylic painting. Be sure to choose brushes designed for acrylic painting—natural bristle or synthetic brushes—which will stand up to the rigor of painting in acrylic and mixed media. Do not try to paint in acrylic with watercolor brushes; they are too soft and floppy. Watercolor brushes are meant to mop up water, but they will not work well with acrylic paint and you will end up frustrated. Do not spend a lot of money on acrylic paintbrushes; there are great brushes at very reasonable prices. Liquitex Freestyle, Silver Brush Grand Prix and Simmons Signet are all very good and inexpensive. I recommend three sizes of synthetic or bristle bright brushes: ¼" (6mm), ½" (13mm) and 1" (25mm).

Now that you have some brushes, look for some other fun stuff you might start to accumulate in your toolbox for making marks. Acrylic/mixed-media painting is an art form where you are limited only by your creativity in terms of what you might use to make marks on your paintings. Art supply companies have started to pick up on the mixed-media trend and create more expensive tools to replace "finds," but it is more fun and cheaper to scavenge for interesting mark-makers. Go to Technique 7 in Chapter 4 to start accumulating your mark-making tools.

Mixed-Media Materials

Acrylic paint is easily combined with other mediums such as charcoal, pencil, water-soluble crayons, pastels and paper of all kinds. This is commonly referred to as "mixed media" which you will see incorporated in projects throughout this book. For more information on mixed media go to Chapter 4, "Incorporating Mixed Media."

technique1: Make Decisions Before Painting

I'm sure you have run into many rules as you've studied painting. The first thing to remember is that in art there really are no rules, only guidelines that might help you meet your goals. Thinking about some basics of designing a painting before you start will help to produce more successful paintings and create a process to walk through each time you set up to paint. One thing to remember is that much of what you will read in painting books refers to a traditional or realistic style of painting and may not apply to the expressive style of painting. The more you paint, the more intuitive these decisions will become. Your eye will begin to train itself to create your favorite compositions without having to think as hard; it will just look right to you. But for now, think about these things and write them in your Painting Notes as reference for the next painting.

Decision 1: Painting Surface Size and Shape

The choice of painting surface size and shape is the first step in composing a painting. Decisions should be made based on the subject matter and your intentions, not on sofa size. Very small paintings create intimacy by forcing the viewer to come closer, but they run the risk of being overlooked. Large paintings demand attention and can create moods varying from enveloping the viewer to aggression depending on the approach. The choice of shape for your painting ranges from squares to verticals to landscapes and even includes round paintings. Think about the size and shape that will best suit your intentions. If you find yourself always painting the same size or shape, purposely step out of the box and do something radically different; it may spark lots of new ideas.

Decision 2: Pick Your Sweet Spots

One easy way to find a natural location for the focal point of your painting is to employ the Rule of Thirds. If you divide a canvas into thirds vertically and horizontally, the intersections of the right angle lines will fall at what are natural focal points for a painting. These are the so-called "sweet spots" where the eye will naturally gravitate. If you place a center of interest in one of these spots, the painting will appear balanced and "right" to the human eye. Of course, you could decide to purposely not choose a sweet spot for your focal point or not have a focal point at all—the choice is yours—but try to make it a choice and not an accident.

Decision 3: Variation of Elements

Paintings are more dynamic when there is variation of elements in the painting. Choices to consider include object sizes, the spaces between objects and the number of objects (uneven numbers often work best for some reason). It also includes any kind of contrast (value, color, size, shape) that attracts and holds the eye of the viewer.

Decision 4: Perspective

The expressionist painters transformed the idea of perspective or how objects are perceived on the picture plane beyond the previous scientific or traditional notions of Western painting. Unusual perspective is one of the elements that distinguishes expressive painting from traditional. That doesn't mean that you can't use more traditional models of perspective in expressive painting, but it does mean that you are not limited to a realistic style of perspective. It's useful to be aware of other approaches you can use to design your paintings. Three models of perspective include:

- *Linear Perspective:* Although it is likely the Greeks and Romans knew about linear perspective, that knowledge was rediscovered in the 1400s by Italian architect Brunelleschi when he described a mathematical system of "lines of sight" stretching to a single vanishing point in the distance. This idea quickly caught on with painters of the era as a device to convey distance in their paintings.
- *Aerial Perspective:* Dutch painters were using aerial perspective in the fifteenth century, and it was utilized in the work of Leonardo da Vinci as well during this era. Aerial perspective is based on the fact that atmosphere (dust and moisture) causes objects in the distance to be hazy or less distinct and slightly cooler. By cooling and lightening paint colors in the background, painters create a sense of distance in landscape painting, a technique used by most plein-air landscape painters today.
- *Subjective or Conceptual Perspective:* In the early twentieth century, Cubism fractured traditional tenets of painting. Avant-garde artists broke through longstanding boundaries and redefined all aspects of painting including perspective. Conceptual perspective is often described as personal, distorted, quirky or flat perspective. In reality, Chinese, Japanese and

Islamic artists had used subjective perspective for thousands of years, but it was introduced in Western art by Cubist painters such as Georges Braque and Pablo Picasso. An example of a contemporary artist who utilizes conceptual perspective is British artist David Hockney. (He's on my personal Artist Ancestors list for this reason!)

Decision 5: Composition Designs

These patterns have been successfully used to map the image on the surface. I always get a kick out of the unwritten rule espoused by many art teachers that one should "never place a focal point in the middle of a painting." Take a look at the work of Georgia O'Keeffe who does this consistently; it's one of her favorite devices. I believe anything is possible in expressive painting if you can make it work; that's part of the charm of this style of painting. But in the spirit of learning the rules so you can break the rules, here are a few tried-and-true ideas for composition designs you might consider:

- *S Shapes:* Curving S-shaped lines lead the viewer into a painting. This design is often used by landscape painters but could be used in any composition.
- *Rectangular Shapes:* Right angled lines, which divide the painting into unequal rectangular sections, give the painting an element of stability or solidness. This design seems to be used by many abstract painters these days.
- *Diagonal Lines and Triangular Shapes:* These tend to be more exciting than rectangles or circles and add a sense of movement to a painting.
- *Clustering Shapes:* These create a natural focal point.
- *Radically Altered Scale:* Seeing a relationship between two objects that we are not used to seeing can create curiosity in the viewer.
- *Altered Viewpoints:* Viewing objects from above or below the typical side view will draw the viewer's eye.
- *Placing the Focal Point in the Middle:* OK, I added this one. Take a cue from O'Keeffe and defy the norm!

what you need

- Painting Notes sketchbook
- pencils or favorite pens

There are other decisions to be made before you begin to paint that have an important impact on the final piece. In the beginning, create a page in your Painting Notes for each new painting and make decisions on the items below and jot down some notes for future reference. This technique is designed to help you develop a consistent method of designing paintings that you can replicate each time.

1. Before you begin a painting, answer the following questions on a page in your Painting Notes. Be sure to add the date.
 What is the subject of the painting?
 What is my inspiration?
 What color scheme will I use?
 What mood do I want to convey?
 What mediums/materials do I plan to use?

2. Next, consider the following and write down the answers in your Painting Notes:
 Canvas or a panel?
 Size?
 Canvas shape?

3. Do several thumbnail sketches of possible compositions in your Painting Notes. When you have finished the painting, come back to your Painting Notes and record your thoughts about the results:
 What worked? What didn't work?
 Jot down some ideas of what you would like to try the next time. Some ideas might include:
 - Design a painting with very strong contrasts of light/dark or warm/cool.
 - Paint a series of the same subject on different shapes/sizes of canvas.

technique 2: Set Up to Paint

Like any other task, setting up to paint is half the battle. If it's too daunting, it won't happen, so it's important to develop a routine and set up the same every time. It will make setup go quicker and make your job of painting easier. If at all possible, find a spot in your home where you can consistently paint and not have to put everything away after each session. (Maybe the kitchen table might not work?) If you are short on space, find a rolling cart you can put all of your supplies on and then push it into the corner when you are done for the day. If everything goes back on shelves or in boxes or the garage, you are less likely to want to pull it back out frequently.

The following is a list of basic materials and setup for acrylic/mixed-media painting. You will find that the longer you paint, the more materials you acquire and the more space you need. Look around your home and think creatively about spaces you might claim as your painting spot. I know people who have turned that seldom used guest bedroom or formal dining room gathering dust into a wonderful studio. Be creative!

what you need

- acrylic medium, fluid (polymer gloss medium, acrylic glazing liquid, GAC-100 or matte medium)
- acrylic paint, medium tubes of professional quality in a warm and a cool of each primary color plus white

 blues: Ultramarine Blue, Phthalo Blue (Green Shade)

 reds: Cadmium Red Medium, Quinacridone Magenta

 yellows: Cadmium Yellow Medium, Cadmium Yellow Light or Lemon Yellow

 Titanium White

- acrylic paintbrushes: synthetic or bristle bright shaped brushes: ¼", ½" and 1" (6mm, 13mm and 25mm) sizes

- apron or painting shirt
- canvases or panels, your choice of size and shape (inexpensive from hobby store is fine to begin)
- easel or flat surface to paint on
- optional: sealable palette, mixed-media elements, disposable gloves, music
- Painting Notes, sketchbook and/or computer as reference
- palette sheets, disposable, or a roll of parchment paper and tape
- rags or paper towels
- water container and spray bottle

1. Find your spot to paint in your home or studio preferably where you can leave your setup between painting sessions. Near a window is nice or you can purchase a clip-on reflector light.
2. Set up your easel or table so that brushes, the mixing surface, paints and the water container are on your dominant side—left for lefties, right for righties. If you are using a stand-up easel, place a small table or cart on your dominant side to hold supplies.
3. Consult your Painting Notes for references, select your inspiration and make preliminary thumbnail sketches.
4. Decide on the size, shape and orientation (horizontal or vertical) of your painting surface (canvas, panel or board) and place it on the easel or table.
5. Arrange your setup so light from the window or a spotlight is shining over your shoulder and onto the painting surface.
6. Secure the painting surface on the easel or flat on a table. You may need clamps to hold the painting surface securely so it doesn't move as you paint.
7. When ready to begin painting, place quarter-sized amounts of heavy-body acrylic paint colors for your chosen color scheme around the paper palette in pools—use the same order each time—warm colors to cool to white, leaving the center open for mixing colors.
8. Fill your water container for rinsing your brush, and place rags or paper towels nearby. Fill your spray bottle and lightly spray pools of paint; remember to do this periodically to avoid drying, which will form a skin over the paint pools.
9. Decide on your color scheme and create a swatch of possible color mixtures.

quick tip

Keep in mind these "painting words of wisdom."
- Dark to Light
- Thin to Thick
- Simple to Detail
- No Sections Left Behind
- Make Every Shape Different—Size, Value, Color, Temperature

quick tip

Because acrylic paint dries so quickly, a plastic bead box is a great idea for holding reservoirs of acrylic paint. The boxes are readily obtainable from your local craft store and should have enough compartments to hold your palette of colors (eight to twelve should work) and a lid that snaps closed. Place a damp thin sponge or a thick paper towel in the lid and keep it moist with your spray bottle. Keep the lid snapped shut when you are taking breaks and overnight. Be sure to periodically spray water on pools of paint inside the box. This will alleviate the problem of wasting paint by dispensing too much on your palette which may dry up while you are painting.

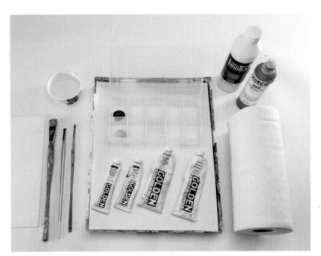

If you are using a bead box to store your paint, add paint to the wells and set up a disposable palette to the side for mixing paint. If you are using fluid acrylic paint, use small cups to hold a small amount of paint in the colors you plan to use.

Basic Painting Process

1 Underpaint the surface of the panel or canvas with a thin mixture of acrylic paint and water in a color from your color scheme.

2 Using the underpainting color, create a map of three to five major shapes on the surface using your Painting Notes plan for the painting composition.

3 Loosely block in the darkest shapes in the design with paint mixed with acrylic medium, keeping the paint thin.

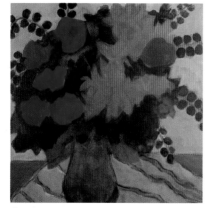

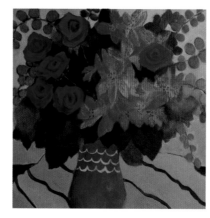

5 Begin to add more layers of paint in variations of your color scheme, checking for color and value contrast between shapes. Continue adding mixtures of paint in variations of color until the entire surface has been covered with at least three layers of paint.

Add small details last in the final touches of the painting, paying attention to dark/light, warm/cool contrasts. Allow to dry prior to adding final finish.

4 Loosely block in the lightest lights of the design with paint mixed with acrylic medium, keeping the paint thin. Continue blocking in until the entire surface has one layer of paint.

reminders

- Always bring the entire painting along together by not moving on to the next level of detail until the entire surface has been covered with the current level.
- If you desire a thicker paint consistency, add thicker mediums as you add layers of paint. Remember: Always work thin to thick!
- Periodically, spray water onto pools of paint on your palette to avoid paint drying and creating a skin over the paint. Depending on the humidity you may want to spray acrylic paint every fifteen to thirty minutes.
- When finished painting for the day, wash your brushes out thoroughly with soap and water. Acrylic paint will harden and ruin most brushes overnight, and leaving brushes in water for prolonged periods will eventually destroy them. I prefer Murphy's Oil Soap to wash brushes, but many people use a bar of Ivory soap.

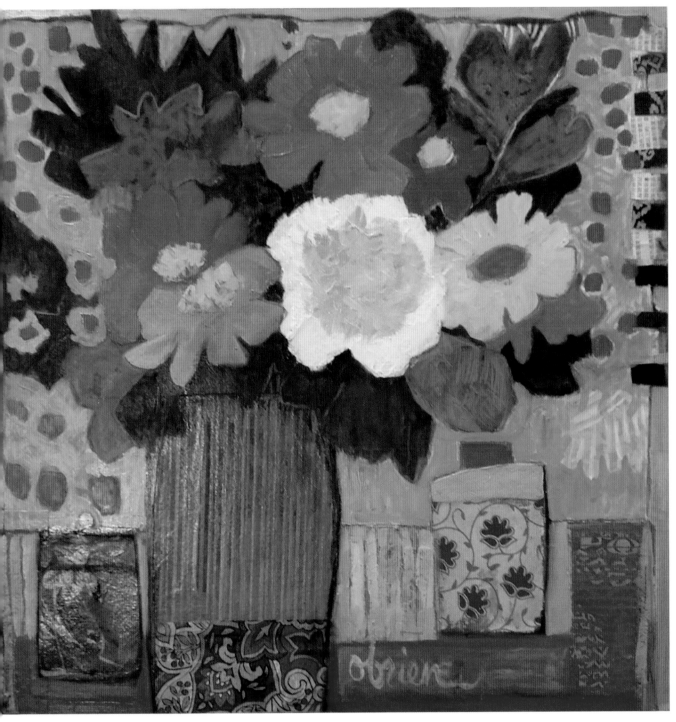

▲ SUMMER FANTASY
Acrylic and mixed media on panel
20" × 20" (51cm × 51cm)

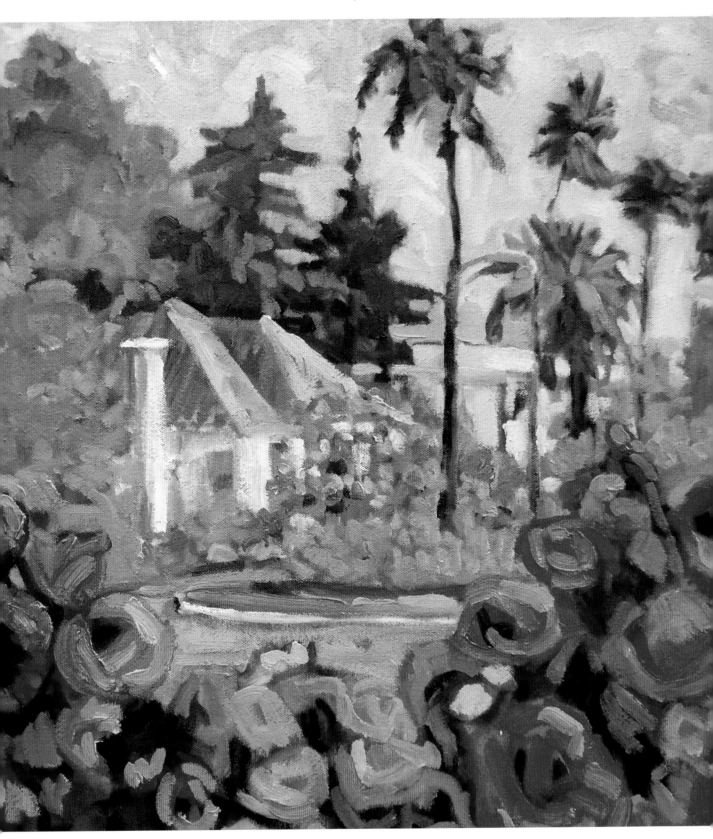

▲ **ON THE AVENUE**
Acrylic on canvas
20" × 20" (51cm × 51cm)

▶ **YELLOW CHAIR**
Acrylic on canvas
20" × 16" (51cm × 41cm)

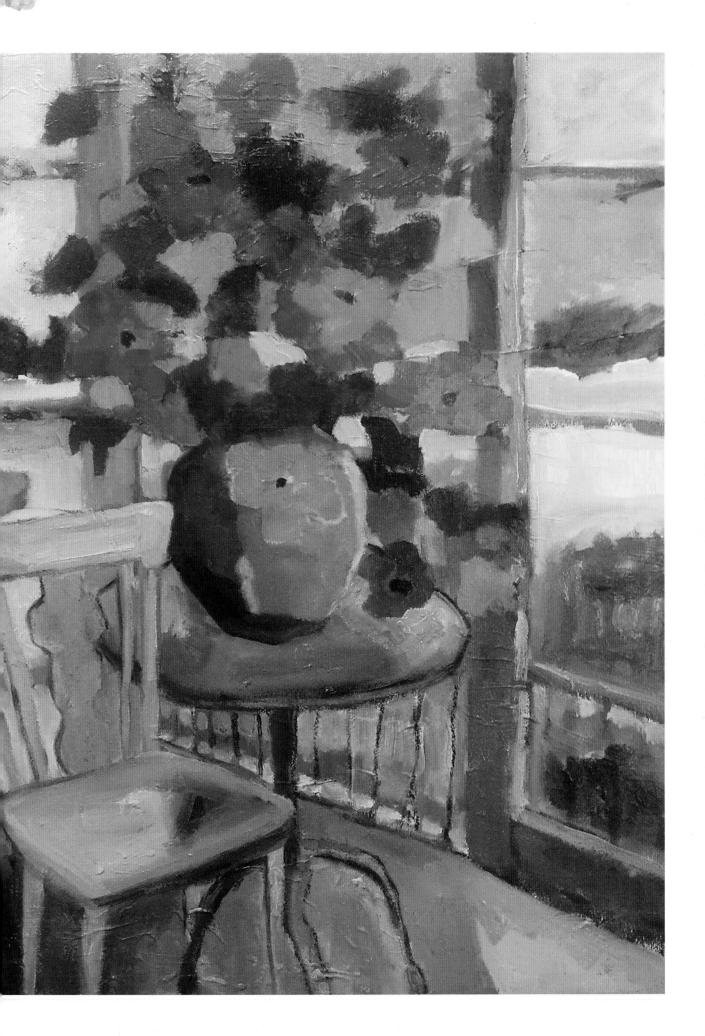

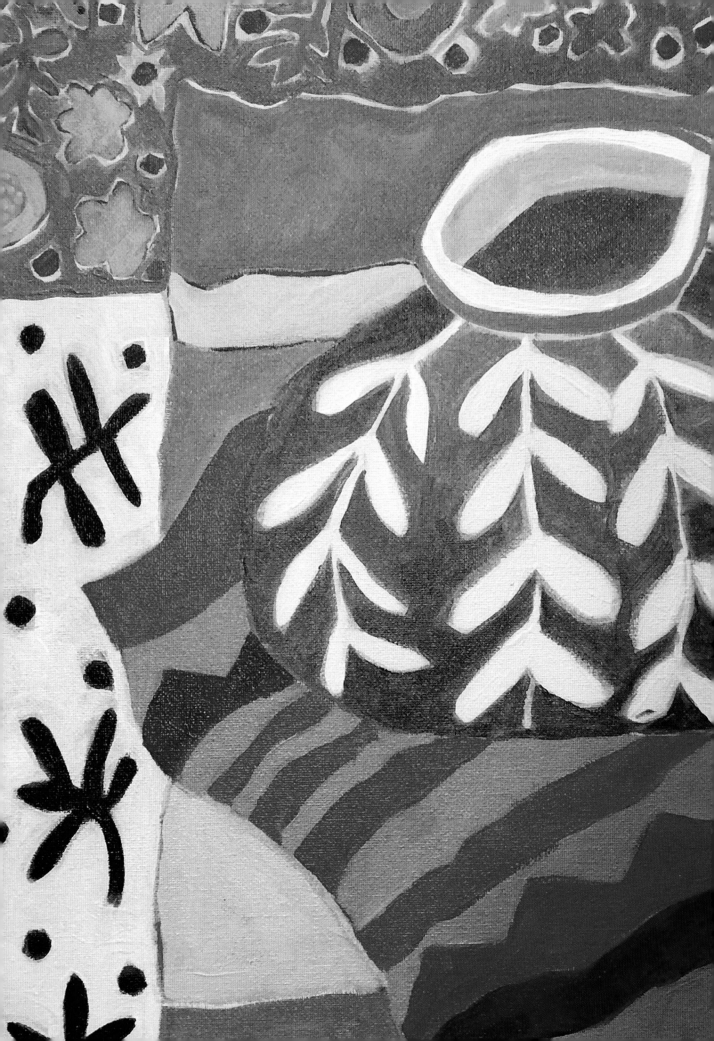

essentials of expressive painting

One day, I found myself saying… 'I can't live where I want to. I can't even say what I want to.' I decided I was a very stupid fool not to at least paint as I wanted to.

—GEORGIA O'KEEFFE

This chapter explores the Elements of Art and the Principles of Design and how they are used in expressive painting. Particular attention is devoted to color and value and how to generate and record ideas for use of key elements in your expressive paintings.

◀ **SANTA FE SUMMER**
Acrylic on canvas
20" × 16" (51cm × 41cm)

What is Expressive Painting?

Prior to the turn of the twentieth century, Impressionist painters like Claude Monet had begun to flaunt traditional painting by fracturing light in their work, a radical departure from painting "reality." In response, some painters rejected the Impressionist concentration on technique and began to focus on a subjective emotional approach to painting. Painters who pioneered this style of painting were lumped together by art historians as Post-Impressionists (Gauguin, van Gogh, Seurat and Cézanne). Subsequent reactions gave rise to the German Expressionist movement, which evolved into many offshoots including the Fauves, of which Matisse is the most famous member. Although none of these painters painted alike, they shared expressive attributes and became known as Expressionists.

This seismic shift in painting in the early twentieth century gave rise to many other expressive movements in painting as the century progressed, including the major Abstract Expressionist movement in New York after WWII. All of this is to say that we are now at a point in history where painters have the choice to paint in any manner they choose. The expressive style of painting no longer denotes a movement as such but an approach to painting in which the artist is not bound by reality but is free to paint subjective responses to the objects, events and the environment in general. Although there may be many definitions of expressive painting and not everyone would agree on a single definition, there are certain key ideas that set the expressive approach apart from realism and other styles of painting.

key ideas of expressive painting

Personal approach to color and shape
Use of pattern
Flat or distorted perspective
Abstraction of nature
Active brushstrokes
Emphasis on aesthetics
Intuitive approach
Symbolic personal meanings

▶ **QUEEN PALM**
Acrylic on canvas
24" × 18" (61cm × 46cm)

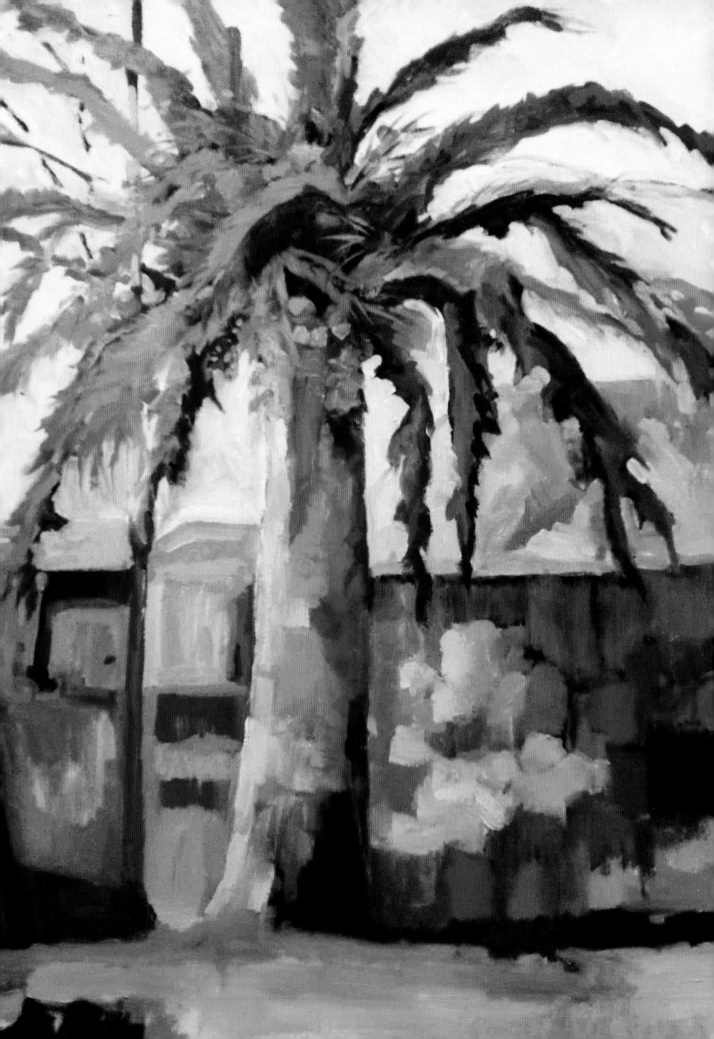

Language of Art

It's important for every artist to understand the basic language of painting—the Elements of Art and the Principles of Design. Any language has its parts of speech and structure, and art does as well. The Elements of Art are the ingredients, or parts of speech, and the Principles of Design are how you put them together to make sense. You must work from a guide until you become fluent in the language. The Elements of Art and Principles of Design are basic components of every work of art.

Whether you are aware of it or not, you are making decisions about the elements and principles each time you create a work of art. Make a cheat sheet listing the elements and principles on an index card and post it in your work space. Create a page in your Painting Notes for each one and find works of art in magazine clippings that illustrate each of them. Use these guides actively as a reference for designing and critiquing your own work until the checklist becomes second nature to you. When you get stuck, ask yourself if the piece would benefit by emphasizing one of the elements? When you critique your own work, use the elements and principles as a framework.

Elements of Art

- *Lines* are marks made by tools, or two shapes coming together that have greater length than width. When lines take different paths they convey different emotions due to the associations our brains automatically put together. For example, a horizontal line suggests a landscape because it represents the horizon in our brain. Horizons denote a sense of stability. Diagonal lines suggest movement because they are jetting off to somewhere and not parallel to the earth. Vertical lines give a feeling of height and when you put horizontals and verticals into right angles together, they create structures that our brains perceive as solid forms. Curving lines are the most sensual because they suggest natural forms including plants, flowers and the curves of the human body.
- *Shapes* are enclosed by lines and defined by their edges. Shapes can be either organic and curving, suggesting nature or geometric like squares, rectangles, hexagons, etc.
- *Texture* can be visual or tactile. Tactile texture is created by brushstrokes or material mixed with paint such as collage or mixed media or mediums such as pumice or glass beads. Visual texture is created through the use of pattern.
- *Value* is the lightness or darkness within a painting usually measured on a scale of one to five.
- *Color* is created by the refraction of light on pigment particles; some rays are reflected and some are absorbed creating various colors.
- There are only three *primary colors* (also known as hues): red, yellow and blue. These are colors that cannot be created through mixing other colors; hence they are referred to as primaries.
- *Secondary colors* are created by mixing two primary colors as follows: red+yellow=orange, yellow+blue=green and red+blue=purple.
- *Tertiary colors* are a mixture of a primary color with a secondary color: red/orange, orange/yellow, yellow/green, green/blue, blue/purple, purple/red.

Principles of Design

The Principles of Design apply to all types of design including paintings, consumer goods, advertising. Any visual medium benefits from effective use of design. The Principles of Design describe how the Elements of Art are put together within a painting. They are the spoken language used by artists, designers, collectors, gallerists and curators to discuss and critique art. They include:

- *Unity* refers to the sense that the elements within a design are working in harmony to create a coherent whole.
- *Pattern* applies to the repetition of a symbol or element across the design.
- *Rhythm* occurs when the repetition of shapes, colors or patterns creates a movement or "beat" that suggests motion.
- *Balance* is the appearance of equilibrium among the objects, colors and spaces within a design.
- *Proportion and scale* refer to the relationship of the size of elements or objects to one another and in reference to reality.
- *Emphasis* is created when one element of a design, such as a focal point, contrast, color, temperature, value or scale, draws the eye to a certain area.

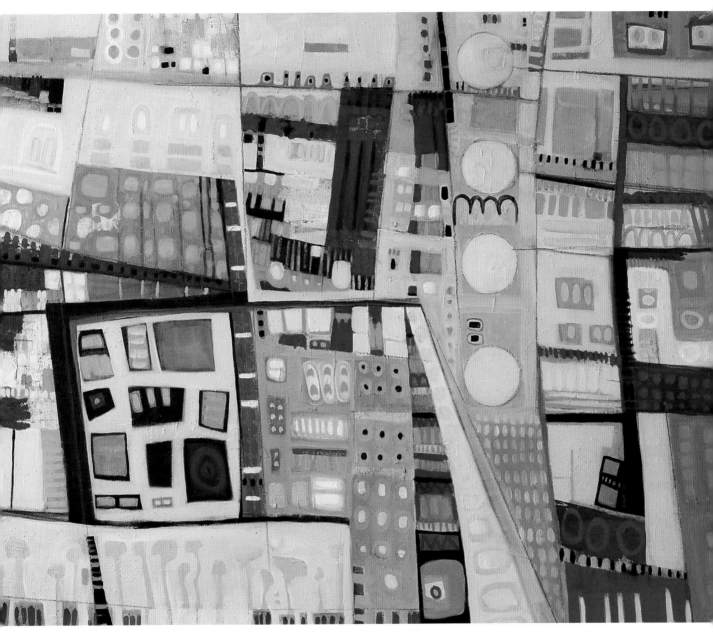

▲ **PERSPECTIVES - SANTA FE**
Acrylic and mixed media on canvas
30" × 40" (76cm × 102cm)

project 5: Create a Line and Shape Library

Creating your own style is something all painters are anxious to achieve. One way to begin to distinguish your work is to incorporate lines and shapes that are pleasing to you and to repeat them in your work so they become your icons. This project will encourage you to create a library of lines, marks and shapes to use in your work.

Artists who distinctively use line as a primary element in their work include Henri Matisse, Andy Warhol, Bridget Riley and Jackson Pollock.

Artists who distinctively used shape as a primary element in their work include Kandinsky, Picasso, Matisse and O'Keeffe.

what you need

- drawing pencils
- line, mark and shape examples (magazines, advertising, fabrics, artwork, animals, flowers, etc.)
- Painting Notes sketchbook
- permanent pen, black

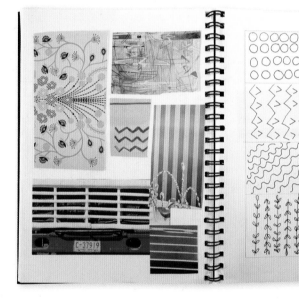

1 Collect samples of lines and shapes from magazines, fabrics, nature, etc. and glue or tape these to pages in your Painting Notes.

2 Practice drawing collections of lines, marks and shapes, using a pencil. Go over final elements you like with a pen.

Continue to create an ongoing catalog or library that you can refer to for paintings. You will be surprised how often you consult these!

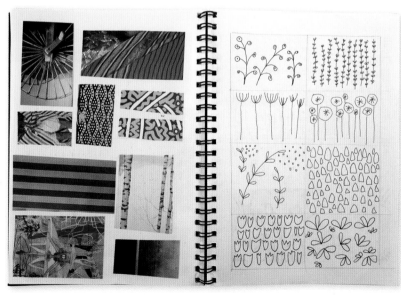

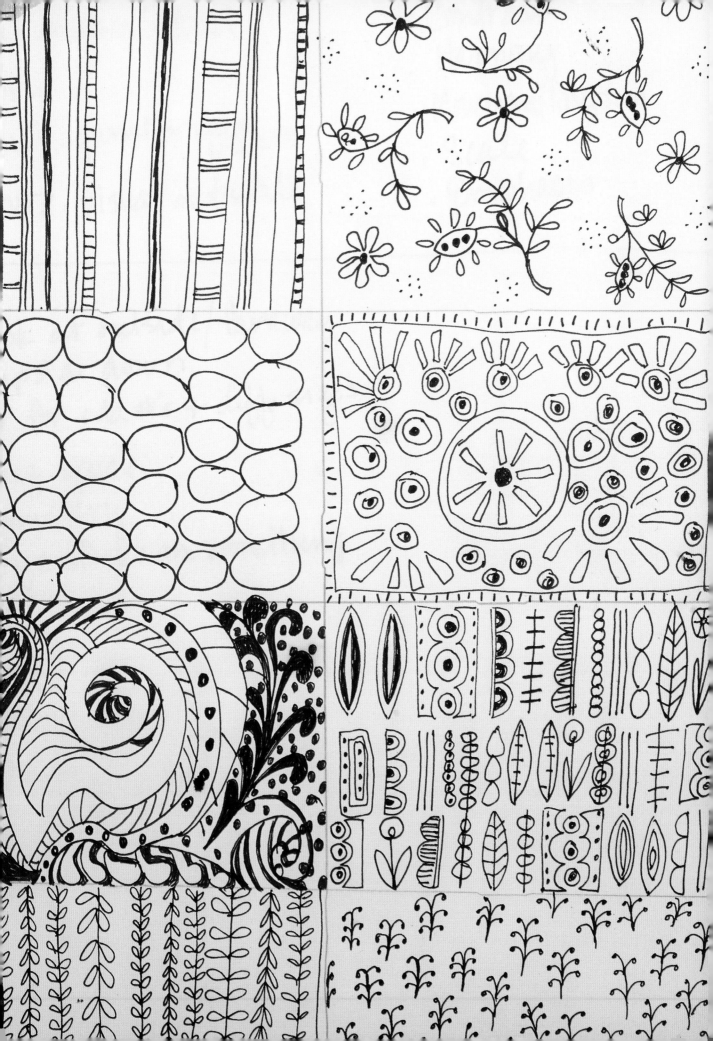

technique 3: Learn to Assess Value

I'm not sure who first said "Color gets the credit while value does all the work," but it is a true statement. What does value refer to in painting? It is simply the range of dark to light contrast. The strongest value contrast is black next to white. If you look at your work and it seems to be missing something, think value contrast first. There seems to be a natural tendency to steer towards middle gray values in paintings because it is difficult at times to determine the value of various colors. A painting that is all middle values can look very bland.

Unless you are striving for a serene look with little pop to it, you need to make a point of assessing the value contrast in each painting. Strong value contrast can increase the excitement in an otherwise dull painting. Deliberate use of strong value contrasts next to each other will reliably pull the eye to that area of a painting. You can use this understanding to your advantage. Remember that every color possesses its own value, which can be refined by mixing to a darker or lighter value level. The value exercise here is intended to make you aware that although color does get the most attention in a painting, value is what makes the painting work.

In this technique you will create a simple three-value scale from white to black to use as a reference to assess value in your paintings. As you paint, compare the values on your painting to the three-value scale by taking a bit of paint on a palette knife or brush and holding it next to the reference scale. If everything is leaning to the middle value (a very common occurrence), try shifting the values to darker or lighter in some areas to create greater contrast that will attract the eye. You can also purchase value scales (some offer a scale five, others offer ten), but mixing a three-value scale of your own and consistently using it will train your eye to assess value difference in your paintings.

what you need

- acrylic paint: Ivory Black, Titanium White
- bristle flat/bright paintbrush, 1" (25mm)
- disposable palette sheet, gray
- heavy watercolor paper, mat board or bristol board, 4" × 6" (10cm × 15cm) scrap
- pencil
- ruler

quick tip

There is also a very good app for your smartphone called "ValueViewer" created by *PleinAir* magazine that will convert photos of your paintings to a gray scale. You can also do this with the camera app on your smartphone just by taking a photo and shifting it to black-and-white mode.

Commercial value finders.

Paint chips may be used as a reference for value.

1. On a piece of heavy watercolor paper or mat board, draw three equal squares.
2. Paint the square on the left end white, and on the right end paint the square pure black.
3. Mix white and black paint to create a middle gray value to fill the middle square.
4. Keep the value scale nearby while you paint and check your value differences near the end of a painting.

quick tip

If you use a gray disposable palette sheet, it is the exact value of a middle gray so you can mix your gray to match the palette sheet!

Understand Color

Of all the elements of painting, color is most associated with the expressive style of painting. Free rein to use color expressively is definitely one of the things that draws me to this style of painting. Color choices are very personal and you most likely gravitate to certain colors in painting just as you do in the rest of your world.

An understanding of color theory is essential to learning to paint but doesn't have to be laborious or painful. Think of gaining a working knowledge of color theory as a series of adventures that you will master. Here are a few basics that you may already know, but I will quickly review as a refresher.

Color Terminology Every Painter Should Know

- *Chroma:* intensity of a particular color
- *Color Palette:* purchased paint colors selected by a painter to place on their palette
- *Color Scheme:* color strategy chosen for a painting, e.g., analogous, complementary
- *Complementary:* two colors directly across from one another on the color wheel
- *Hue:* the color family (red, blue, etc.)
- *Saturation:* soft vs. intense color
- *Shade:* variation on color created by adding black
- *Temperature:* warm vs. cool color. Cool colors include blue, violet, blue-green; warm colors include red, yellow, orange. Color temperature can be relative according to surrounding colors, e.g., a blue can look warm next to a cooler purple.
- *Primary Colors:* colors that cannot be mixed from other colors: red, yellow, blue
- *Secondary Colors:* colors composed by mixing two primary colors: orange, green, purple
- *Tertiary Colors:* colors made by mixing a primary color with a secondary color: red/orange, orange/yellow, yellow/green, green/blue, blue/purple, purple/red.
- *Tint:* variation on color created by adding white
- *Tone:* variation on color created by adding gray
- *Value:* light vs. dark

These basic concepts are easiest to visualize on a color wheel. Take a look at the one on the next page. This is how basic color mixing works, but when you visit the art store you quickly realize that there are lots of variations of the same color, and they are all a little different. This is when things get interesting.

This is why I suggest that to gain mastery over mixing color for your paintings, you plan your color scheme and create swatches of color mixtures from the paints you plan to use before you begin. This is especially important when painting in an expressive style since you are not trying to match reality and have your choice of all colors. Although being released from creating realistic color can be freeing, it can become a bit overwhelming if you have no plan for the color scheme. You can quickly end up with a carnival of colors and then wonder why the painting isn't working. After you have painted many paintings with thoughtfully chosen color schemes, color choice will become second nature. In the beginning, you will save yourself a lot of do-overs if you plan your color scheme in advance by creating color swatches for each painting.

It makes sense to start with what is referred to as a "limited palette" of paint colors. You might be thinking *well that's no fun,* but if you get a handle on the basics of color, you can quickly begin to add other ones that catch your eye. This is why I suggest you start with a warm and cool color of the primary colors (red, yellow, blue) plus white as your starting palette. The next addition should be one of each of the secondary colors (purple, green and orange). You will see that in some of the projects I have added in some of my favorite colors, and you have the choice whether to stick with the basic palette or add some colors you want to try out. Start with the recommended limited palette of colors and systematically use it for a while to learn color mixing using fewer variables, then begin to expand your paint box.

Color is one of the great things in the world that makes life worth living to me.

—GEORGIA O'KEEFFE

There are many variations of each color on the color wheel. Cadmium Red Light and Alizarin Crimson are both red, which makes them primary colors, but they are very different and will yield very different color mixtures as a result. To complicate matters more, there are dozens of secondary and tertiary paint colors with random names produced by different paint companies each with their own twist on color. This is why I have included two exercises to create your own color wheels and color chart using the actual paint colors on hand. As you paint more, you will no doubt want to pick up some other paint colors. You will have to let your tastes and budget be your guide on that. There are excellent, experienced painters who keep their palettes small and mix everything they need from very few colors. If you have a love of certain colors, those might be the ones you add to your paint color collection first.

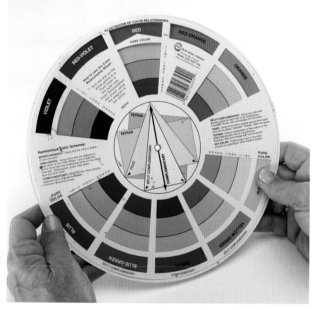

Commercial Color Wheels/Charts

There are wonderful commercial color wheels and color charts on the market, and I suggest everyone buy one at some point because of their ease of use. Commercial color wheels give you a very general idea of what happens when you mix colors but they don't come anywhere close to looking like the actual mixtures you will get from the paint colors you have. They will get you in the right ballpark as far as choosing color but will not tell you which version of the color you can create from your paint.

Basic Warm/Cool Primary Color Palette

Choose a warm and a cool of each of the primary paint colors. Secondary and tertiary colors can be mixed from the variations possible with this palette. The following tube paint colors, plus Titanium White, are a great starting point.

- Cadmium Yellow Medium (warm)
- Lemon Yellow (cool)
- Cadmium Red Light (warm)
- Alizarin Crimson or Quinacridone Magenta (cool)
- Ultramarine Blue (warm)
- Phthalo Blue (Green Shade) (cool)

Basic Warm/Cool Secondary Color Palette

If you want to add secondary colors to your collection, I suggest the following:

- Cadmium Orange (warm)
- Naples Yellow (cool)
- Sap Green (warm)
- Phthalo Green (cool)
- Dioxazine Purple (warm)
- Quinacridone or Cobalt Violet (cool)

Basic Neutrals Color Palette

Some neutrals or earth colors you might want to add:

- Yellow Ochre
- Burnt Sienna
- Raw Umber
- Titan Buff

Black Color Palette

If I need black for a painting I usually choose:

- Ivory Black

Most often I mix a "black" using:

- Alizarin Crimson + Ultramarine Blue or Phthalo Green

project 6: Create a Personal Color Chart

A focused approach to mixing color is important when learning to paint and will pay off in the long run. It is too easy to start throwing colors together, and this can lead to confusion and frustration with poor results. A little structured practice with color mixing will go a long way to helping you harness the power of color in your work.

quick tip

Acrylic paint comes in many variations of primary colors, for example, Manganese, Cerulean and Phthalo Turquoise are all blues. You may want to create new charts as you try out new versions of primary colors.

quick tip

Sometimes the use of the term *palette* can be confusing. There is the palette you place your paint on (glass or disposable palette sheets), and then there are the colors you select for a particular painting which is also called your "palette" or "color palette." You will have both.

what you need

- acrylic paint, medium tubes of professional quality in a warm and a cool of each primary color plus white:

 blues: Ultramarine Blue, Phthalo Blue (Green Shade)

 reds: Cadmium Red Medium, Quinacridone Magenta

 yellows: Cadmium Yellow Medium, Cadmium Yellow Light or Lemon Yellow

 Titanium White
- bristle flat/bright paintbrush, 1" (25mm)
- heavy watercolor paper, mat board or bristol board, 12" square (30cm)
- paper towels or rags
- pencil
- ruler
- water container

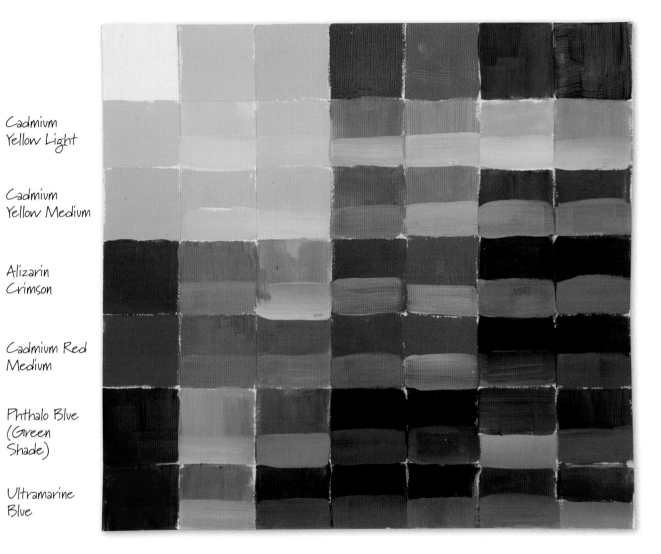

Cadmium
Yellow Light

Cadmium
Yellow Medium

Alizarin
Crimson

Cadmium Red
Medium

Phthalo Blue
(Green
Shade)

Ultramarine
Blue

1. On the mat board, draw a large square and divide it into an equally spaced grid of seven squares on each side. Remember to leave the square on the top upper left blank to allow the color mixtures to meet correctly across the chart.
2. Leaving the first square blank, label the blocks along the left side of the grid with the names of the tube paint colors. (You may also wish to label the tops of the rows with the same colors in the same order as the left side, to make it easier to remember.)
3. Fill in the first row across and the first column on the left with pure paint colors from the tubes.
4. Mix colors as they intersect across the grid and add paint mixtures to those boxes.
5. Optional: Mix tints of each color by adding white to each one and dabbing a bit on the squares.

project 7: Create a Personal Color Wheel

A commercial color wheel provides general information about primary, secondary and tertiary colors and what happens when you mix them. I suggest that all artists buy and keep a commercial color wheel nearby especially when you are learning to mix color. But you will not learn about the actual mixtures created by the paint colors you chose at the art store from a commercial color wheel. It only serves as a general reference.

I advise you to create your own color wheel from your particular paint colors. There's no substitute for learning what happens from mixing particular hues of color. This is a good reason to start with what is called a "limited palette," one tube of each primary and secondary color.

1 On the mat board, draw a circle using a compass or a dinner plate as your template. Divide the circle into six equal pie-shaped wedges by drawing a line dividing the circle in half, then dividing each half into thirds.

quick tip

You may want to do this exercise again as you acquire other colors of paint to see what a difference the variations on hues can make.

suggested basic paint colors

Basic Warm/Cool Primary Paint Colors:
- Cadmium Yellow Medium (warm)
- Lemon Yellow (cool)
- Cadmium Red Medium (warm)
- Alizarin Crimson or Quinacridone Magenta (cool)
- Ultramarine Blue (warm)
- Phthalo Blue (Green Shade) (cool)

Expanded Primary/Secondary Paint Colors:
- Cadmium Orange (warm)
- Indian Yellow (cool)
- Sap Green (warm)
- Phthalo Green (cool)
- Dioxazine Purple (warm)
- Quinacridone or Cobalt Violet (cool)

2 Draw a smaller circle in the center of the larger circle. Paint red, blue and yellow primary colors in three wedges around the circle with a blank wedge between each primary color.

Paint orange, purple and green secondary colors between the primary colors. For example, purple will be between the red and blue wedges—right?

Mix each color with some white and begin filling each of the inner portions of the wedge with the mixtures to provide you with tints of each. For example, the mixture of yellow and white will go in the inner section of the yellow wedge.

 Continue until each wedge is filled.

technique 4: Create Go-To Color Schemes

A color scheme refers to a plan of color chosen for a particular painting. Choosing a color scheme for a painting in advance will help to harness the expressive painter's fervor to use every color on one painting. I recommend gaining mastery of the following three simple color schemes as a systematic way to gain control of color in your work. After completing many paintings, color schemes will become intuitive for most painters. But early on, it helps to use the analytical brain to solve some of the issues involved in creating a powerful painting.

- *Monochromatic:* OK, I know what you are thinking—monochromatic=boring. But wait, just try it. Using a monochromatic color scheme allows you to simplify color choice down to one color and then develop variations on that color by creating *tints:* color+white, *tones:* color+gray and *shades:* color+black. Plus, you can choose many different variations on one color to create new mixtures. You will be surprised by how great this combination is and how much fun it is to mix all of these variations on one color. The other benefit of this scheme is that it always works; it will always be cohesive and will allow you to feature other elements in your painting such as texture or shape.

what you need

- acrylic paint, medium tubes of professional quality in three primary and three secondary colors plus Titanium White (Stick to either all warm or cool with all six. See suggested paint colors under Create a Personal Color Wheel.)
- bristle flat/bright paintbrush, 1" (25mm)
- heavy watercolor paper, mat board or bristol board, scraps
- paper towels or rags
- water container

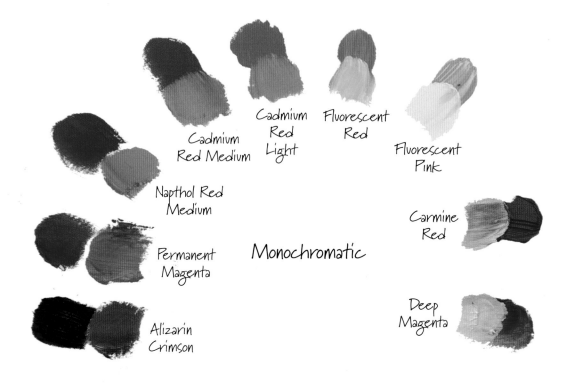

Cadmium Red Medium

Cadmium Red Light

Fluorescent Red

Fluorescent Pink

Napthol Red Medium

Carmine Red

Permanent Magenta

Monochromatic

Alizarin Crimson

Deep Magenta

- **Analogous:** Analogous colors are those that sit next to each other on the color wheel. In an analogous color scheme, you choose three to four "neighboring colors." You can use all of the variations of the colors within that section of the color wheel that you have selected. This scheme is always harmonious.
- **Complementary:** Complementary color schemes will give you the most bang for your buck. Colors opposite each other on the color wheel are referred to as complements and they have the most contrast. Look at advertising or sports teams and you will see mostly complementary color schemes in use. The Fauvist painters such as Matisse frequently used complementary color schemes. Use this scheme when you want to shout with color.

In this technique you will create color charts for Monochromatic, Analogous, and Complementary Color Schemes done with your favorite colors. There are many variations on the same hues available (e.g., Cobalt Blue, Cerulean Blue, Phthalo Blue), so your choice of which particular color will greatly affect the mixtures you create. In the beginning, I recommend choosing your color scheme and paint colors, and creating a color swatch as a reference for each painting you do.

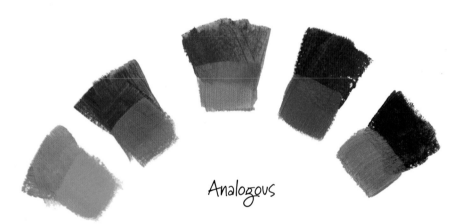

Analogous

1. Create color swatches on a scrap piece of watercolor paper or mat board with various mixtures of paint colors for each of the following color schemes: monochromatic, analogous, complementary.
2. Label each swatch with the tube color of paint used and do as many combinations as you desire.
3. Keep these swatches nearby as you paint and consult them frequently.

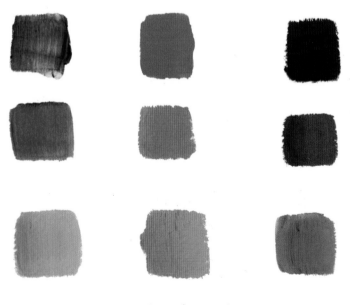

Complementary

technique 5: Mix and Match Color

As expressive painters we are not tied to painting reality. We can paint with any colors that express what we are trying to convey. But one of the measures of competent painting is knowing how you got there in terms of color. Maybe you have a particular color you want to create or a painting you completed and you wonder *how did I get that color?* Learning to mix color accurately and to match color is a skill that anyone can learn. In this technique you will use paint swatches from the hardware store and challenge yourself to mix and match the colors.

what you need

- acrylic paint, medium tubes of professional quality in three primary and three secondary colors plus Titanium White
- bristle flat/bright paintbrush, ½" (13mm)
- heavy watercolor paper, mat board or bristol board, 12" square (30cm)
- paint chips, various colors
- palette paper, disposable
- paper towels or rags
- pencil
- water container

1. Select a paint chip and attach it to the mat board. On your disposable palette paper start to match the color by first selecting the basic hue closest to the color of the chip.
2. Analyze the chip color and decide what you need to mix with the basic hue to get to that color. Hint: think warmer or cooler? Brighter or duller? What do you need to add to match the color on the chip?
3. Once you are close to mixing the color that matches the hue, add enough white or black to match the value of the color. You may not get this on the first try but keep trying.
4. Record the paint colors you used on the mat board and save your color matching samples as references for your paintings.

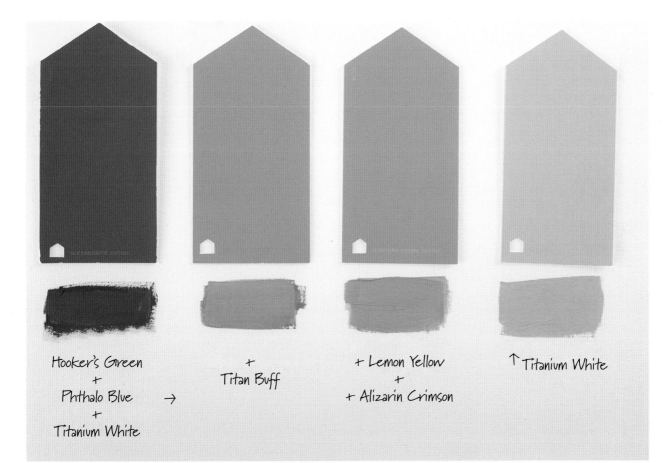

Hooker's Green
+
Phthalo Blue →
+
Titanium White

+
Titan Buff

+ Lemon Yellow
+
+ Alizarin Crimson

↑ Titanium White

technique 6: Mix Beautiful Neutrals

Every new painter fears making "muddy" color. I'm guessing this comes from back in grade school when we were given school-grade paints and water and left to "go to it," which usually meant we mixed all the colors together and most of the time got mud! It could possibly also come from previous attempts at painting that involved grabbing a little of this and a little of that color without any thought to how colors mix.

I have two thoughts on this issue that should put to rest any fears of muddy color. First, muddy color is easily avoided by understanding some simple basics of color theory. Second, muddy colors are just neutrals which are beautiful and necessary to successful painting, and purposely creating them needs to be learned as part of color mixing. Bold colors appear more striking when balanced with beautiful neutrals.

"Mud" or neutrals are created by mixing complementary colors (the ones directly across from each other on the color wheel) together. Neutralizing bright tube colors is a skill that is necessary to create complexity in paintings. Remember all you have to do to dull down or neutralize a bright color is add its complementary color. If you mix a blue paint with an orange paint, you will get a neutral gray that will lean towards cool (more blue) or warm (more orange). The same thing will happen when you mix red colors with green colors or yellows with purples—just slightly different variations on neutrals. Try intentionally mixing neutral colors from the paints you have on hand. Experiment with graying down, which is a method of neutralizing colors by adding a touch of their complementary color to take the edge off a color that might be too bold. This is a great way to add interest and complexity to your painting. Start with a small touch of the complementary color and add more as needed. To achieve a lighter neutral, add a little white paint.

All neutrals possess a color bias: They lean towards cool or warm. You will quickly begin to create neutral mixtures intuitively. Just ask yourself if the neutral you are looking for is warm or cool, dark or light and adjust accordingly. Then try out some of your beautiful neutrals next to some bold colors. *Remember, if you are trying to avoid mud, don't mix a color with its complementary color, the one across the color wheel, right?

what you need

- acrylic paint, medium tubes of professional quality in three primary and three secondary colors plus Titanium White
- bristle flat/bright paintbrush, ½" (13mm)
- color wheel
- heavy watercolor paper, mat board or bristol board, 12" square (30cm)
- paper towels or rags
- water container

1 Choose a primary color and the secondary color directly across from it on the color wheel—its complementary color. Paint swatches of each on the mat board or watercolor paper. Then mix some of each together to create a neutral color. Swatch this below and between the two colors. Add a bit of white to the neutral mixture and add a swatch of that tint. Add more white, then add a final swatch.

Begin the process again with a new set of complementary colors.

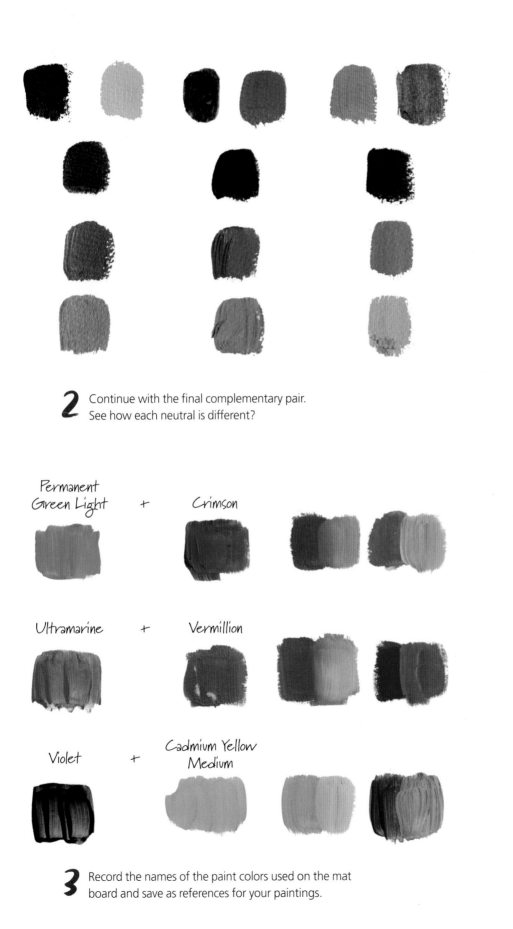

2 Continue with the final complementary pair.
See how each neutral is different?

Permanent
Green Light + Crimson

Ultramarine + Vermillion

Violet + Cadmium Yellow
Medium

3 Record the names of the paint colors used on the mat
board and save as references for your paintings.

incorporating mixed media

Ask anyone doing truly creative work, and they'll tell you the truth: They don't know where the good stuff comes from. They just show up and do their thing. Every day.

—AUSTIN KLEON

Mixed media simply means the use of more than one medium (paint, paper, clay, etc.) in the same work of art. Mixed-media techniques are always expanding as new art materials and artists' imaginations continue to evolve.

Although almost anything goes with mixed media, try one or two techniques rather than throwing all of them on one piece. The following techniques are some of my favorites that I use consistently in my work and are some basics you can draw from to enhance your paintings.

◄ **ALEXANDER'S GARDEN 3 (DETAIL)**
Acrylic and mixed media on panel
30" × 60" (76cm × 152cm)

project 8: Make an Expressive Underpainting

I am frequently asked by painters, especially those just getting started, how they can learn to stay looser. I always recommend starting off with loose underpaintings. Repeat after me: "Start loose, stay loose!" These processes for creating underpaintings will get you off to an expressive start. They are very simple but an important part of the expressive painting process. You may also find shapes that suggest a composition for the painting in your loose underpaintings. The idea behind these directions is to not overthink, just apply color and marks loosely and randomly. Even if it is eventually painted over, a loose expressive underpainting creates character in the painting. It also serves two other purposes: 1. It will get you into the habit of starting loosely, and 2. It quickly eliminates the "scary white canvas" that can inhibit starting a painting. Try using all of these methods at least once and hopefully you will find one that resonates with your style.

Option 1: Basic Expressive Underpainting

what you need

- acrylic paints, professional-grade, your preferred color scheme
- canvas or panel
- scraping tools (bowl scraper, plastic key card, squeegee, cardboard, etc.)
- spray bottle for water

1 Turn on your favorite music and let loose! Put a blob of one color onto a painting surface and spread randomly and thinly with scraping tools.

2 Spritz water onto the surface periodically and allow the water to drip and/or move across the surface with scraping tools. Repeat with at least three different colors. Allow to dry.

Option 2: Underpainting with Marks

what you need

- acrylic paint markers
- acrylic paints, fluid professional-grade, your preferred color scheme
- canvas or panel
- scraping tools (bowl scraper, plastic key card, squeegee, cardboard, etc.)
- water-soluble crayons or colored pencils

1 Using different sizes of mark-making tools, randomly scribble marks. Here I've started with graphite and an acrylic paint marker.

2 Drip fluid acrylic paint across the canvas or panel and spread randomly and thinly with scraping tools.

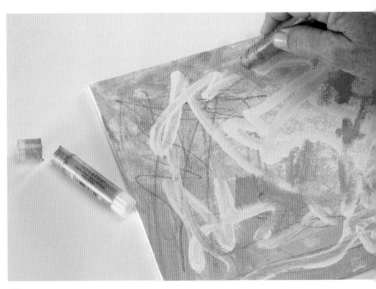

3 Repeat several times with other colors or other mark-making mediums, such as water-soluble crayons. Additional fluid acrylic can be applied thinly, too. Allow to dry.

quick tip

Consider doing several underpaintings in one session. Another option is to use leftover paint at the end of a painting session to create underpaintings for the next session.

Option 3: Adding Collage Paper

what you need

- acrylic matte medium
- canvas or panel
- foam brush or old brush
- paper, various (newspaper, tissue paper, scrapbooking paper, handmade paper, etc.)

quick tip

Here are some additional ideas to try with your under-painting.

- Apply additional paint using stencils randomly and freely.
- Spray water onto the surface and apply patterned paper. Roll with a brayer to remove paint in sections creating patterns.

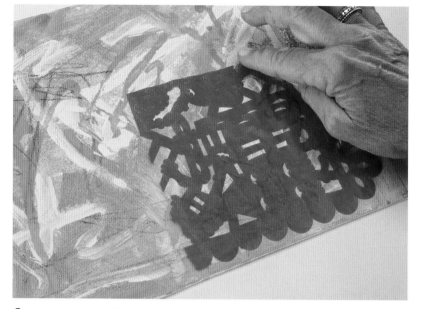

1 Apply matte medium to sections of the panel. Adhere torn pieces of collage paper over the wet medium. Keep in mind this is still an underpainting and you're building texture here. Don't get too attached to imagery on the paper itself; you will likely be covering it at least in part.

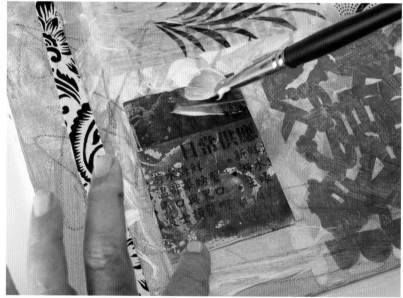

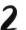 **2** Brush additional medium over the paper. Repeat with as many pieces of paper as feel good to you. Allow to dry.

▶ **FIESTA**
Acrylic and mixed media on canvas
20" × 16" (51cm × 41cm)

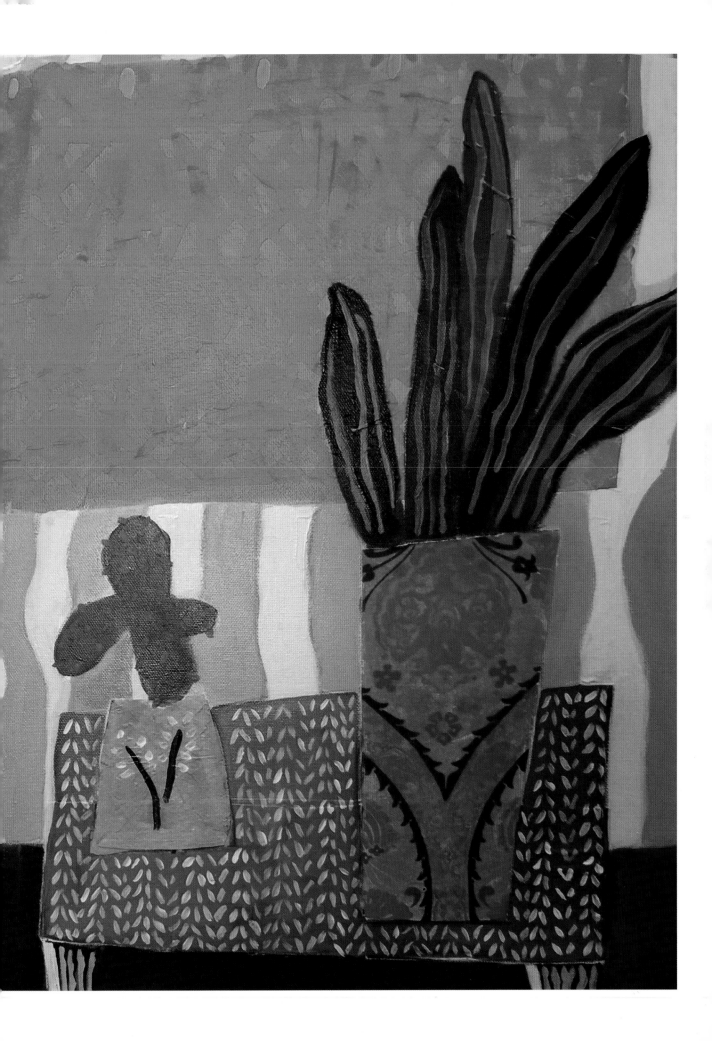

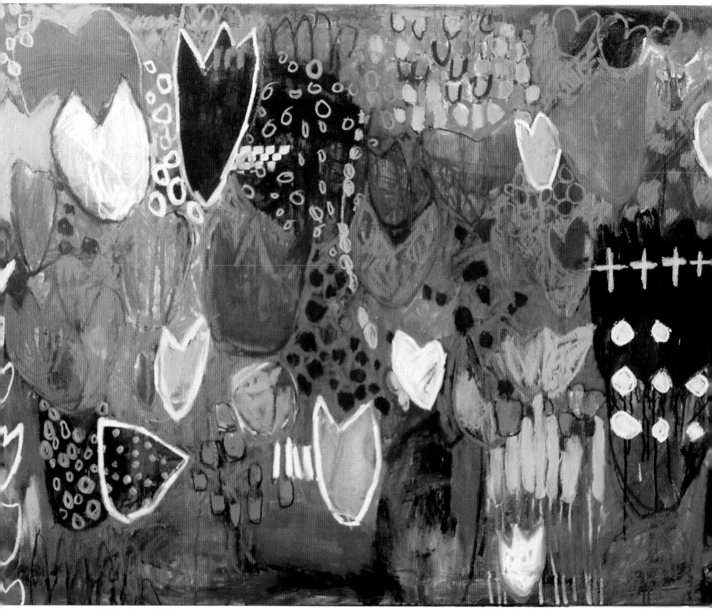

▲ **TULIPMANIA REDUX**
Acrylic and mixed media on panel
36" × 48" (91cm × 122cm)

▶ **TULIPMANIA 3**
Acrylic and mixed media on panel
48" × 36" (122cm × 91cm)

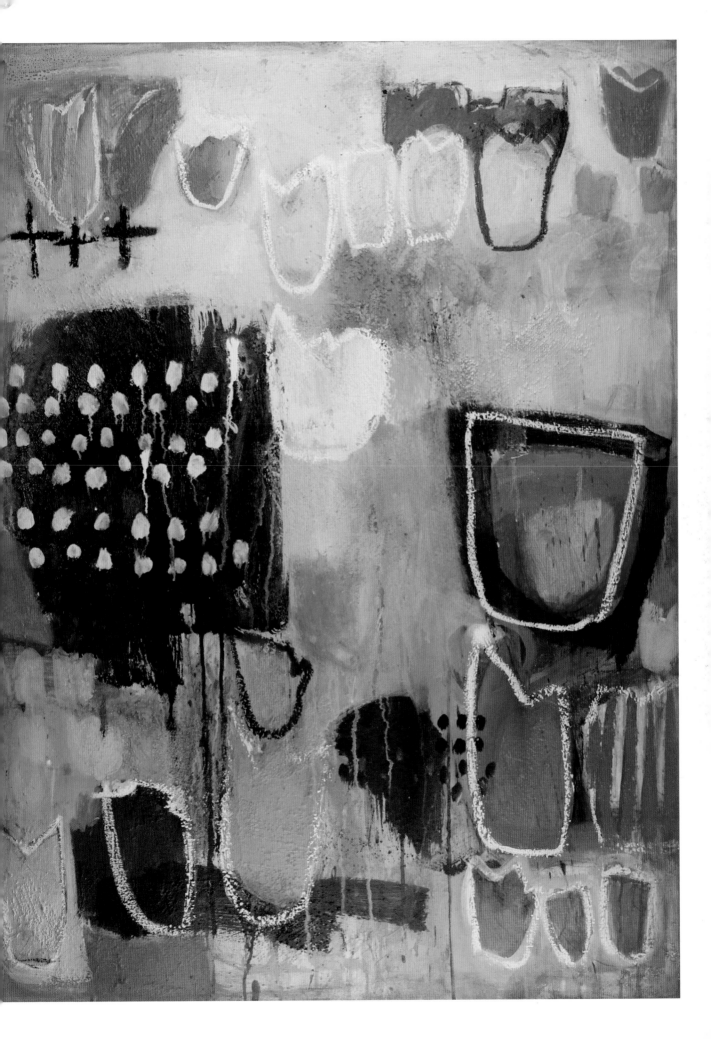

project 9: Create Collage Materials

Option 1: Painted Paper

what you need

- acrylic ink
- acrylic paint, fluid
- paper (newspapers, washi paper, wrapping paper, old book pages, paper bags, etc.)
- scraper and/or brayer
- spray bottle for water

Pablo Picasso popularized collage in the early twentieth century by incorporating paper ephemera into his paintings. Since then, artists have interpreted collage to include almost anything. Collecting and creating paper for collage is an addictive pastime once you get started.

Adding collage elements to expressive paintings is an intuitive process, so it's nice to have a stash of materials ready when the need arises. You will quickly need to come up with storage solutions. Storing by color in plastic translucent boxes works well.

Start looking around you for paper ephemera—for collage material—and you will find it everywhere. Start your search in your home. You will no doubt find paper bags,

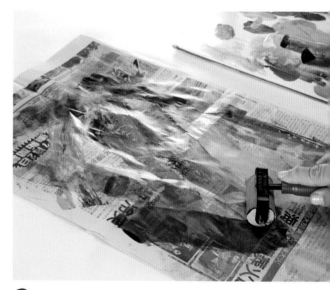

1 Lay out lots of paper on a plastic dropcloth or layers of newspaper. Dribble fluid acrylic paint, ink or leftover paint across the paper and spread the paint randomly with a scraper.

2 Alternatively, you can use a brayer to spread the paint. Additionally, try spraying with water in places to encourage the paint to create textures. Allow to dry.

quick tip

If you are looking for vintage style, copyright-free images for collage, check these resources online:
- Go to Flickr and search "collage images" for over 18,000+ free vintage images
- New York Public Library Picture Collection: www.digital.nypl.org/mmpco
- Smithsonian Institution Flickr Commons photostream: www.flickr.com/photos/smithsonian

junk mail, maps, daily planner pages, stamps, letters, documents, phone books, magazines, catalogs, stationery, wrapping paper, tissue paper, wallpaper, etc. Cruising antique stores, garage sales and flea markets can reap choice collage materials, too. Once you start to look, you will quickly amass a collection. Of course you can always buy beautiful paper at stationery and craft stores, but found paper can be very interesting.

If found paper doesn't appeal to you, you can also create your own collage paper to add interest to your paintings. By creating your own, you increase the choice of colors and textures you'll have available in your stash. I periodically set aside a half day to replenish my stash of painted collage papers. The process can be messy but goes very quickly, so you might as well create a lot while you're in the mode. Get out your materials and clear your tabletops for drying. Here are a few simple ideas for enhancing your collage paper collection.

Method 1

Option 2: Gelli Plate Prints

what you need

- acrylic ink
- acrylic paint, fluid, colors of your choice
- baby wipes
- brayer
- Gelli Arts Gel Printing Plate, size of your choice
- paper (newspapers, sandwich wrap, old book pages, paper bags, etc.)
- spray bottle for water

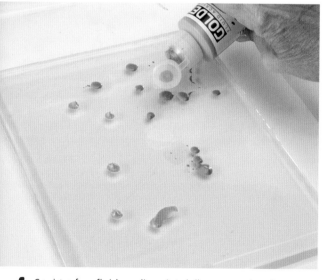

1 Squirt a few fluid acrylic paint dollops onto the plate.

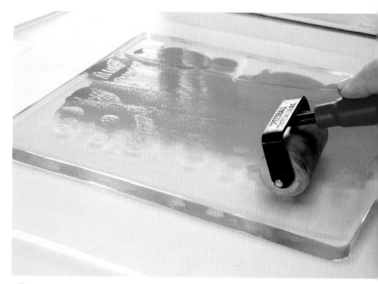

2 Use a brayer to spread the paint.

3 Lay paper onto the plate and smooth with your hands.

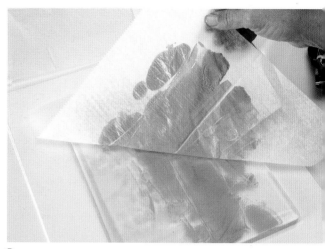

4 Pull the print. (Peel the paper off the printing plate.) If there is sufficient paint still on the plate, smooth down a second piece of paper and pull another print. This second print is called a "ghost print."

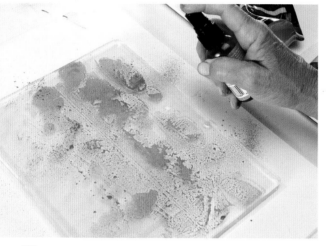

5 Spray the leftover paint with water.

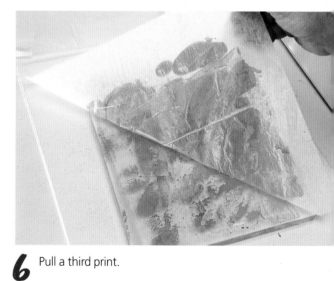

6 Pull a third print.

quick tip

Organize your dry collage papers by color and keep them together with the aid of bulldog clips.

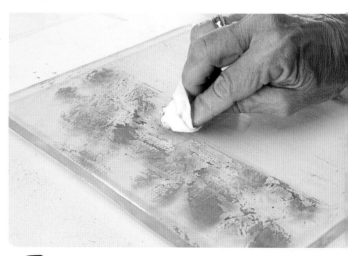

7 Clean any remaining paint off the plate using a baby wipe.

Method 2

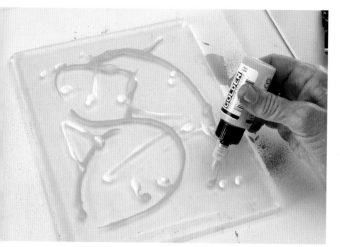

1 Squeeze drops and lines of paint on the plate.

2 Place a piece of paper onto the plate and burnish well using a brayer.

3 Pull the print.

4 Reconstitute the paint by spraying it lightly with water. Add drops of ink to the plate.

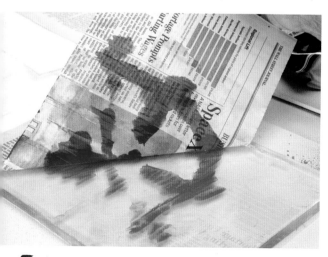

5 Place the same paper onto the plate and pull the print again.

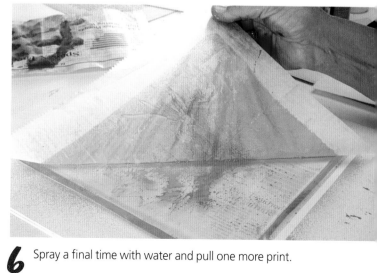

6 Spray a final time with water and pull one more print.

A variety of marks in a painting creates a visual and tactile texture that can add to the complexity and interest of your paintings. Once you begin looking, you will discover the joy of the hunt for unconventional tools to make marks. Grab a tote bag and start the scavenger hunt at home. The first place to start is in your kitchen, searching through the drawers of utensils that are seldom used. Anything from dish scrubbers to mesh produce bags is fair game. The next obvious gold mine for repurposed mark-makers is the garage or toolshed. After you have exhausted your resources on the home front, take a walk outside and collect twigs, seed heads, stones, pinecones, anything that can be used to make marks. Stop off at flea markets, thrift stores, yard sales, discount stores and hardware stores and keep your eye open for finds. Here are a few ideas to get you started:

- Kitchen: skewers, mesh bags, rubber shelf liner, cookie cutters, doilies, paper towels, old place mats
- Hardware store: screen mesh, trowels, paint scrapers, faux painting tools, home décor stencils, drywall tape
- Outdoors: sticks, leaves, rocks, dried flowers, pinecones
- Household: plastic key cards, combs, found papers, junk mail, packing boxes, bubble wrap, wallpaper scraps, foam pieces, sponges

- Art or craft store: palette knives, sculpture or ceramics tools, printmaking tools, rubber stamps, kids' foam stencils
- Recyling (or trash) items: Styrofoam food trays, plastic bottles and lids, plastic wrap, cardboard, packing inserts, cereal and other thin cardboard boxes
- Thrift shops/yard sales: oddly shaped items you can use as stencils or stamps, rough fabrics such as burlap or lace

Stay constantly on the hunt for mark-making tools you can repurpose. Make it a game to try not to buy them. Assemble your newfound tools in a basket or shoebox in your studio and try them out on collage papers or in your Painting Notes sketchbook. Try using these tools in the projects to follow.

what you need

- acrylic paint, fluid
- canvas or panel
- mark-making tools (scrapers, sticks)

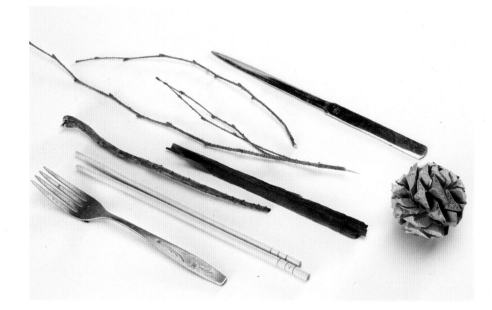

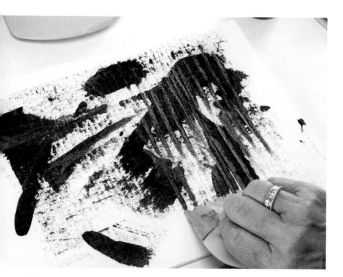

1 Squeeze some paint onto your surface. Try out a combed scraper.

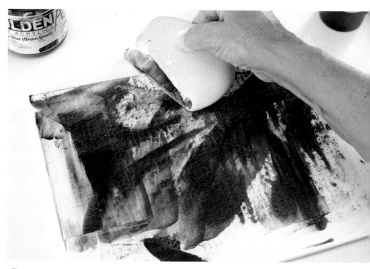

2 Try a pot scraper.

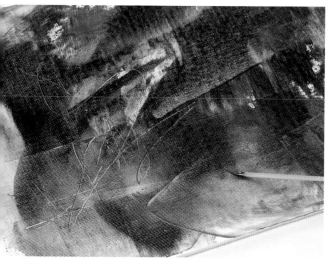

3 See what scratches can be made with a skewer.

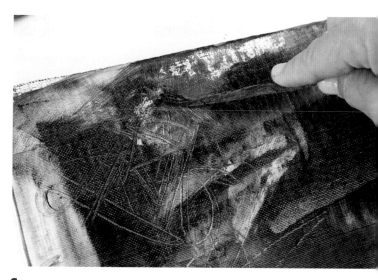

4 Compare the skewer with the marks from a stick.

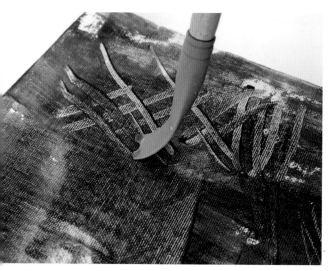

5 Make deliberate marks such as Xs.

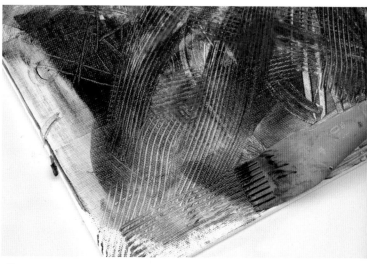

6 See what it looks like to cover a large area with similar marks.

project 10: Cut Your Own Stamp, Stencil and Mask

There are lots of manufactured stamps, stencils and masks out there to embellish your work, but it will make your work unique to create your own. Try your hand at creating stamps, stencils and masks in your own style. It's inexpensive and lots of fun. You might even enlist your kids or grandkids to help you out. The following directions will get you started.

quick tip

Found items can also be used as stamps, stencils or masks as well: leaves, feathers, lace, corrugated cardboard, embossed paper, caps from bottles, odd-shaped objects, etc.

what you need

- acrylic paint
- black pen
- bristle brushes, inexpensive or brushes with worn-out bristles
- cardboard, thin (cereal boxes, frozen pizza boxes, etc.)
- craft foam sheets and shapes with sticky backs from craft store
- glue stick
- scissors

Stamp

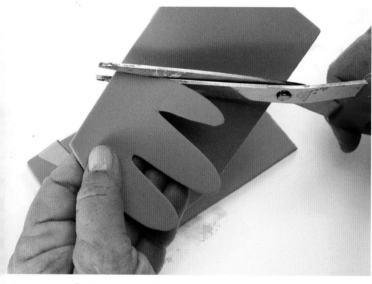

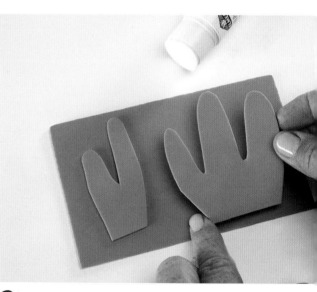

1 Cut a piece of foam to act as the stamp base. Draw your shape (the wilder and looser, the better) on the foam sheet with black pen and cut out (or just eyeball it). Craft foam sheets are thin, so you might want to adhere the cutout to another piece of foam and cut around it again to double the thickness.

2 Attach the cutouts or shapes to a base piece of craft foam using a craft glue stick. Your stamp is now ready to use! Brush it with acrylic paint and stamp it onto your painting.

Stencil

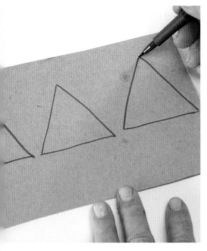
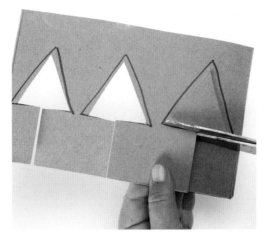
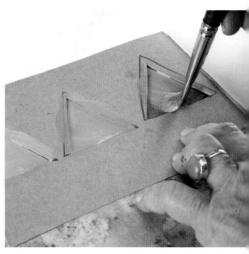

1 Draw shapes onto cardboard with a black pen.

2 Cut out the shapes either by punching a hole in the middle of the shape and inserting the point of your scissors into the hole to begin cutting, or cut from the outside of the cardboard, into and then around the shape. If you do the latter, as shown here, tape the initial cut lines closed.

Try cutting random shapes: circles, stripes, squares, squiggles, anything you can dream up. The idea is to *not* look perfect!

3 Lay the stencil on the painting. Using a small amount of thick, undiluted acrylic paint and a bristle brush, paint over the stencil. Use inward strokes from the surface of the stencil into the shape to avoid paint seeping under the edge of the stencil. To achieve a painterly look, brush paint loosely and thinly.

Mask

1 Cut shapes from craft foam, as you did to create a stamp, or use the cutout pieces of cardboard from a stencil you cut. Place the mask on your painting and paint over it with acrylic paint.

2 Carefully lift up the mask to reveal your negative image.

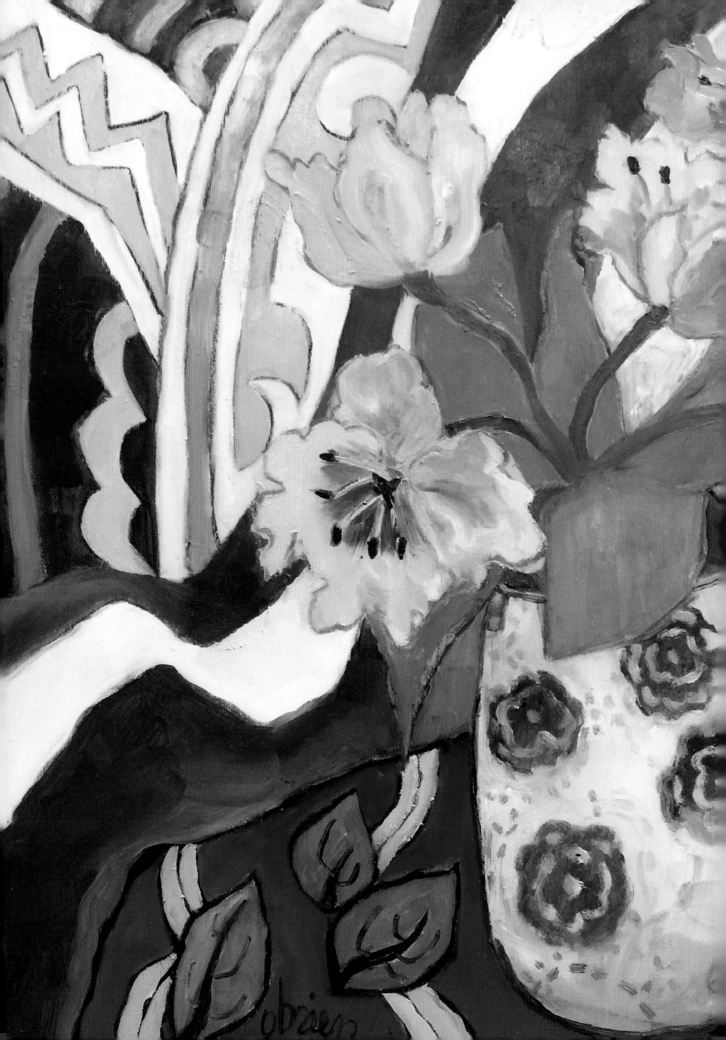

expressive painting projects

If I knew what the picture was going to be like, I wouldn't make it.

—CINDY SHERMAN

By now you've worked your way through a self-assessment, found your inspiration, gathered some ideas, assembled your materials and practiced some of the essentials. You are ready to take on some project paintings. The eight projects here are designed to give you a chance to create complete paintings using the expressive techniques and ideas you have accumulated. These projects can be done in any order that appeals to you. Go back to previous chapters if you need a refresher on certain techniques. It's likely you will find something you love and want to continue. Choose your own subject matter and color palette for any of the projects. Good luck and happy painting!

◀ **FLORAL ABSTRACTION**
Acrylic on canvas
18" × 18" (46cm × 46cm)

project 11: Paint an Aerial Abstraction

This project finds inspiration in aerial photos or maps found on your computer. You will gain practice in transforming reality into the Elements of Painting—line, shape, color, value and texture—that will come together as an abstract painting.

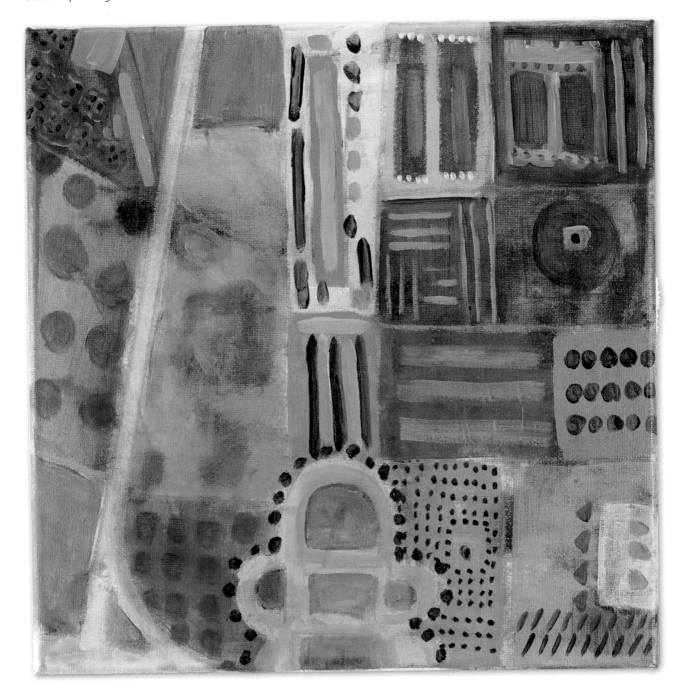

what you need

- acrylic paint, professional-grade, colors from a go-to color scheme of your choice
- canvas or panel, square
- dry pastel
- paintbrushes, synthetic or bristle, bright ¼", ½", 1" (6mm, 13mm, 25mm)
- pencil
- permanent pen, black
- reference photo—aerial view of one of your favorite places using an app such as Google Earth
- tracing paper
- water container

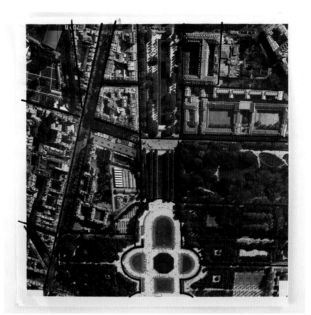

1 Find an aerial photo or map for inspiration and print a copy to use as a reference.

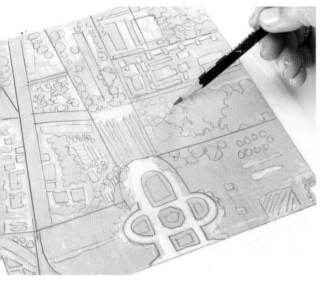

2 Place tracing paper over the photo and outline the larger shapes using a pencil.

3 Trace over your pencil lines with a black permanent pen. Leave out detail for now; just capture the larger shapes in the photo.

4 Decide on a color scheme and create a color swatch. I used analogous greens and blues.

87

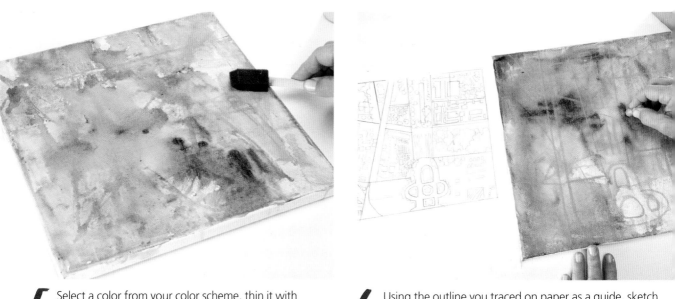

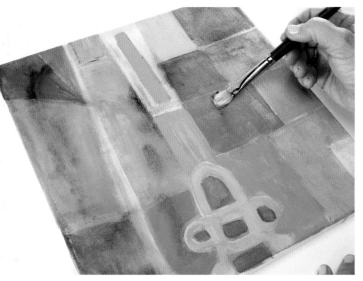

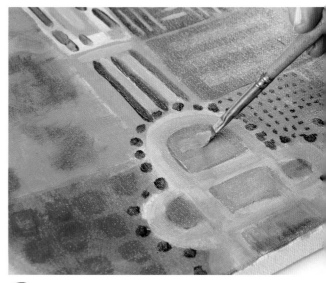

5 Select a color from your color scheme, thin it with water and apply it as a thin underpainting to your surface. Allow the underpainting to dry. I used Phthalo Blue (Green Shade).

6 Using the outline you traced on paper as a guide, sketch the largest shapes onto your canvas using dry pastel.

7 Block in the largest shapes on your surface using the darker paint colors from your color scheme. Create mixtures of colors from your color scheme and begin layering paint onto shapes, paying attention to value and color contrast between shapes. Try to see how many variations of colors you can create from your color scheme.

8 Break up larger shapes into smaller shapes by adding pattern and visual texture in contrasting colors. After two to three layers of paint have been applied, check for value differences (light/dark contrast) between shapes and correct to increase the contrast between shapes. Use the value scale you created in Technique 3 or the ValueViewer app. Apply more paint to correct values and color contrast.

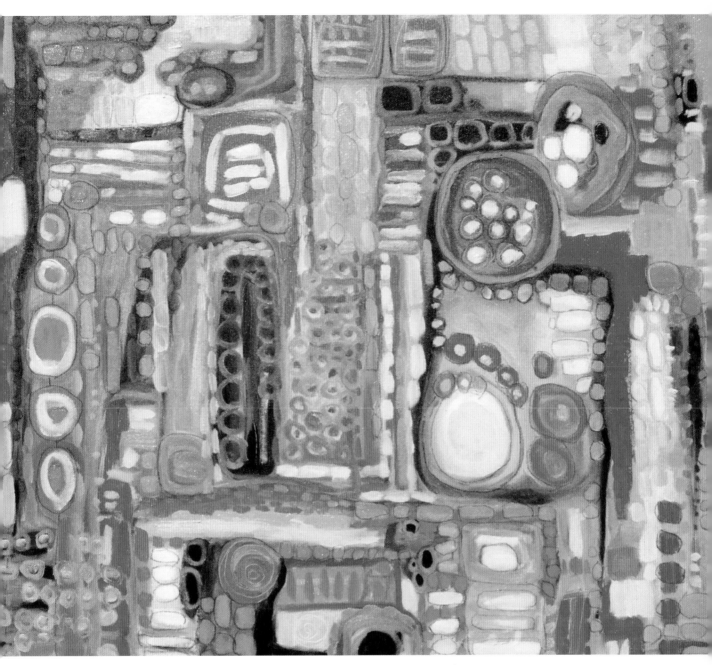

▲ **AERIAL**
Acrylic on canvas
24" × 30" (61cm × 76cm)

project 12: Paint an Expressive Figure

This project was inspired by one of my Artist Ancestors, Gustav Klimt. Klimt was an Austrian painter who emphasized color and pattern in his expressive paintings, two of my favorite elements. This project encourages you to take inspiration from one of your favorite figurative painters and incorporate elements of their style into your own work.

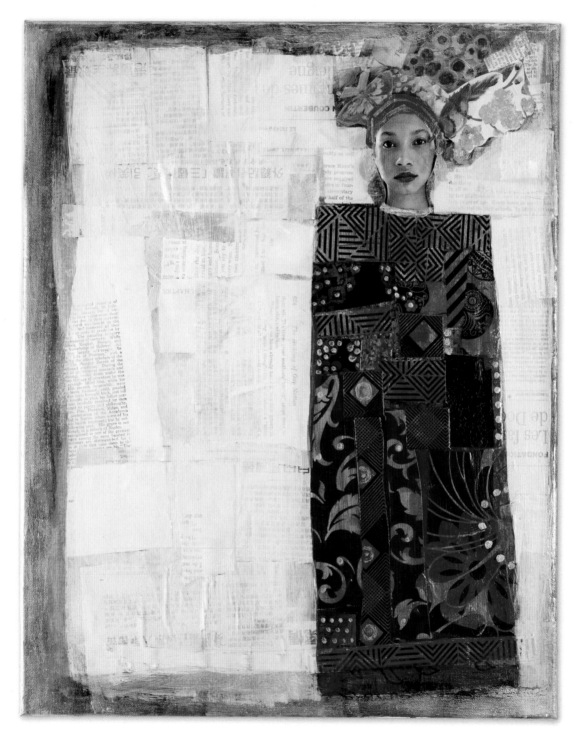

what you need

- acrylic glazing medium or fluid matte medium
- acrylic paint, professional-grade, colors of your choice
- Artist Ancestor analysis from your Painting Notes
- canvas or panel, 12" × 16" (30cm × 41cm) or larger
- collage papers, variety
- five-value strip
- magazine photo of a figure
- mark-making tools
- matte gel medium
- paintbrush, synthetic 1" (25mm)
- scissors

1 Choose an Artist Ancestor from your Painting Notes and review what you've collected to get a sense of your Ancestor's style and the elements he or she uses.

2 Flip through magazines to find a figure that speaks to you (fashion magazines are really great for this) and then obtain a laser copy of the magazine photo at your local copy shop.

3 Select a color scheme and create swatches. Apply a loose, thin underpainting to your surface using several colors from your scheme. Use a variety of mark-making tools.

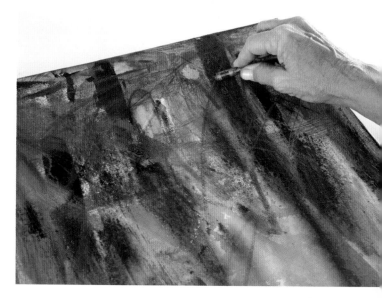

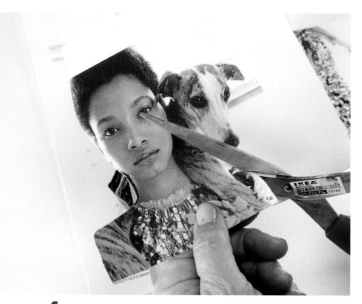

4 Cut out the portion of the figure you wish to use in the painting from the laser copy.

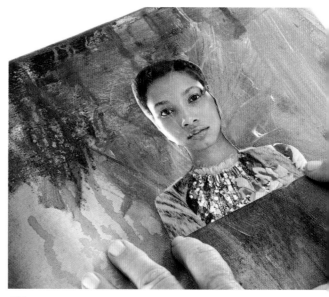

5 Coat your laser copy with matte medium and allow it to dry. Adhere the figure to your surface with additional matte gel medium, brushing over the front of the image as well.

6 If you're using only part of the figure as I did, lightly draw in the shape of the rest of figure; keep it simple! Block in large shapes using collage paper to suggest a clothing shape.

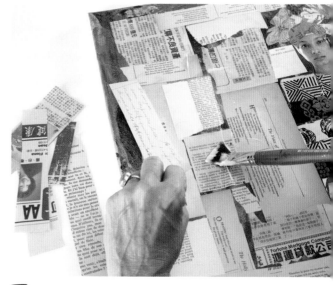

7 Around the figure, adhere a variety of papers to create a background over the underpainting. Words with text work nicely, but any papers will do.

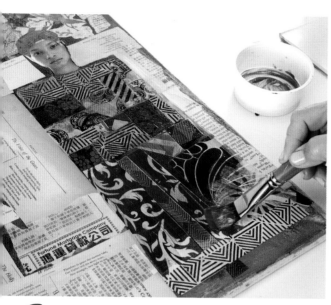

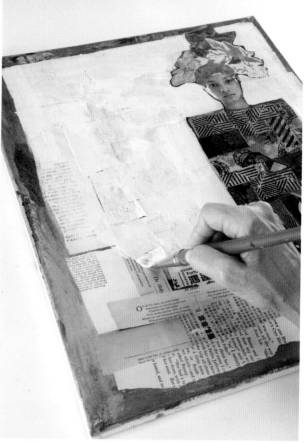

8 Apply a glaze over the clothing using a color mixed with acrylic glazing liquid or fluid matte medium. I used fluid Quinacridone Magenta mixed with acrylic glazing liquid.

9 Add a glaze of thin paint mixed with matte medium to create a veil over the background and allow it to dry.

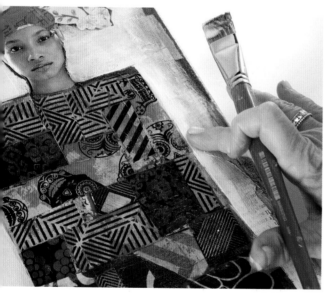

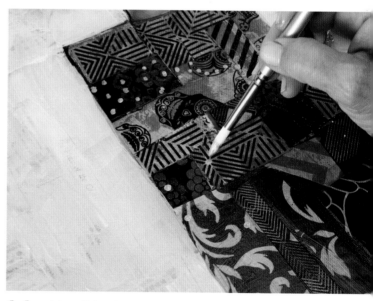

10 Glaze portions of the background with another color (I used Phthalo Turquoise) mixed with acrylic glazing liquid or fluid matte medium to push the background behind the figure.

At this stage, stop and check for value differences between shapes using a five-value strip or the ValueViewer app on your smartphone and correct values to increase contrast.

11 Add small details to your figure with a contrasting paint color. I used fluid Iridescent Gold.

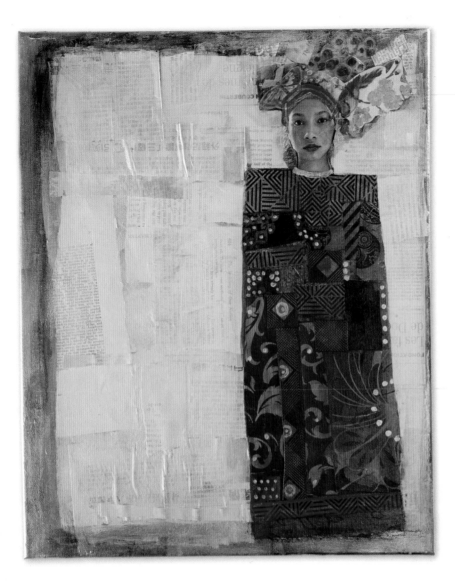

12 Apply a contrasting paint color thinly and loosely around the perimeter of the painting to add extra dimension. I used Iridescent Gold paint. Allow to dry.

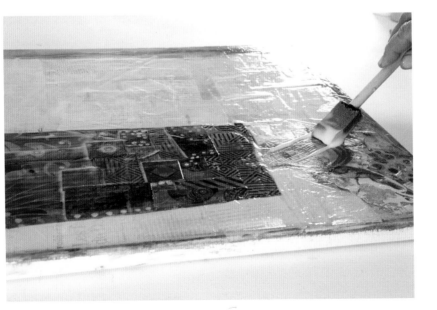

13 Apply the final finish as desired. (See Chapter 6.) I applied Golden Self-Leveling Gel.

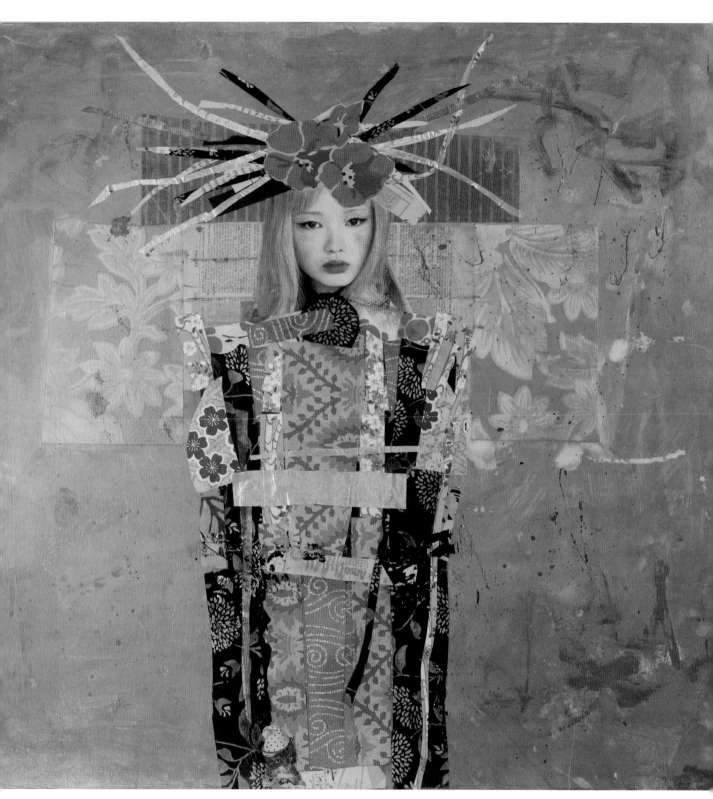

▲ **GREEN AND PINK**
Acrylic and mixed media on panel
20" × 20" (51cm × 51cm)

project 13: Paint an Abstracted Pattern

This project is an exercise in color mixing and seeing variations in value and temperature. Try to paint the color of every shape different from the shape next to it using mixtures from your color scheme. This project could be done on a large scale and become a very interesting geometric abstract painting.

what you need

- acrylic paint, professional-grade, color scheme of your choice
- canvas or panel, square, any size
- paintbrushes, synthetic or bristle, bright ¼", ½", 1" (6mm, 13mm, 25mm)
- pencil or dry pastel

1 Select a shape you love from your Painting Notes as your inspiration. Choose your color scheme and create a color swatch. I used Ultramarine Blue, Phthalo Blue (Green Shade), Phthalo Green (Blue Shade), Green Gold, Cadmium Red Medium, Alizarin Crimson, Quinacridone Magenta, Titan Buff and Nickel Azo Yellow.

2 Create a thin underpainting with a color from your color scheme. I used Nickel Azo Yellow. Using pastel or pencil, repeat the pattern you have chosen to serve as your painting guide. I made horizontal lines then drew triangle shapes.

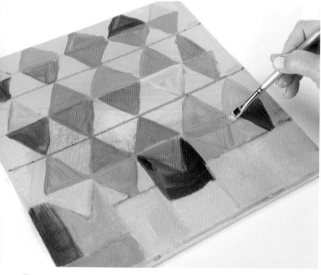

3 Fill in shapes mixing variations of your color scheme. See how many colors and values you can create; make each one different.

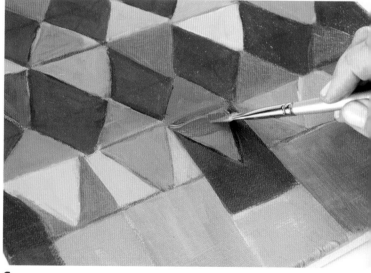

4 Add thicker paint mixtures in another layer, continuing to vary color mixtures within your scheme. Add at least three layers of color to each shape and the spaces in between, checking for color temperature and value contrast. Allow to dry and apply final finish as desired. (See Chapter 6.)

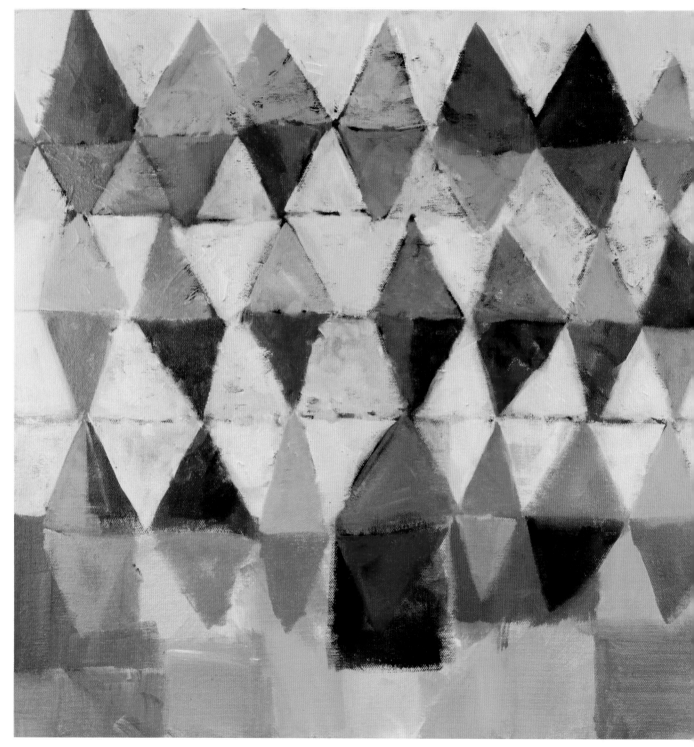

▲ **DIAMONDS**
Acrylic on canvas
18" × 18" (46cm × 46cm)

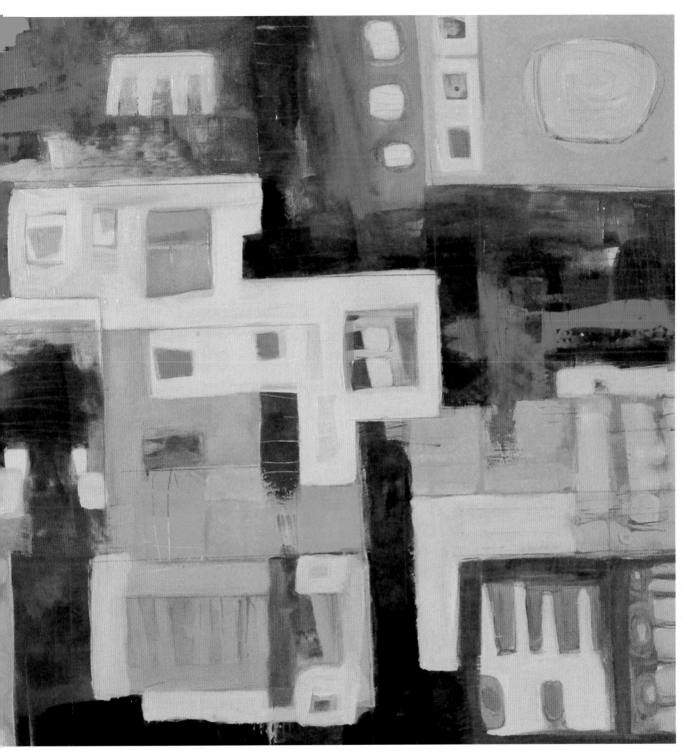

▲ **PLAZA**
Acrylic and mixed media on panel
30" × 30" (76cm × 76cm)

project 14: Paint an Expressive Still Life

I made the decision to embrace technology as one of my painting tools a long time ago. I guess you could say I'm an "early adopter." I take flower and still-life pictures wherever I go so I have a library of photos on my phone. I enjoy playing with art/photo applications on my smartphone and have painted many of the resulting images. There are many applications out now that are amazing tools for the artist. In my mind, these are the modern version of the camera obscura adopted by Renaissance painters to determine linear perspective. Anything that opens new ways of seeing is worth a try. Chances are good that you use your phone or perhaps your tablet device to take photos. I encourage you to explore some of the applications listed below to generate painting inspirations. It's a lot of fun and somewhat addictive.

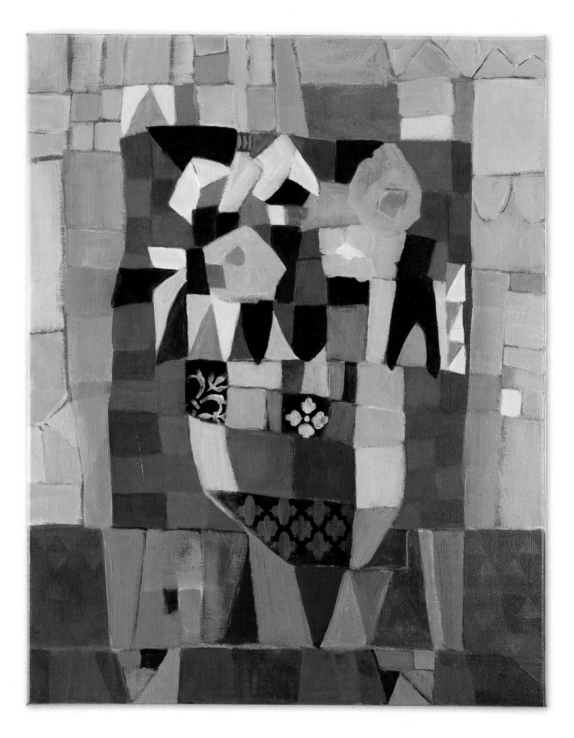

what you need

- acrylic paint, professional-grade, color scheme of your choice
- canvas or panel, 16" × 20" (41cm × 51cm) or larger
- dry pastel
- paintbrushes, synthetic or bristle, bright ¼", ½", 1" (6mm, 13mm, 25mm)
- photo of still life or floral (something from your smartphone is fine)
- smartphone photo applications: Prisma, Pikazo

Still life reference photo transformed by Pikazo photo app.

Before you begin

Take a photo of a still-life or floral scene (or choose one from a magazine and snap a photo) as your inspiration. In this example, I photographed a floral arrangement given to me for Mother's Day. Transform your photo with a smartphone photo application or similar to alter shapes and colors. I used Pikazo for this image. Print your manipulated photo out or use it on your phone as reference.

Decide on a color scheme and create color swatches. I used Rose Fluorescent, Bright Aqua Green, Quinacridone Magenta, Cadmium Red Medium, Cadmium Orange, Cadmium Yellow Medium and Titan Buff.

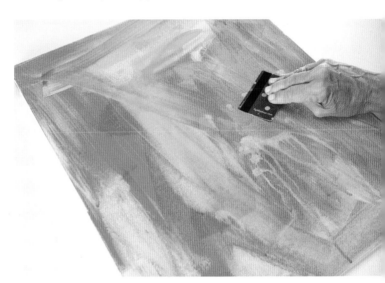

1 Underpaint your canvas or panel with transparent color from your color scheme and allow to dry.

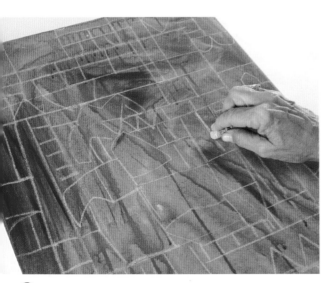

2 Sketch the largest shapes loosely on the canvas with dry pastel in a contrasting color.

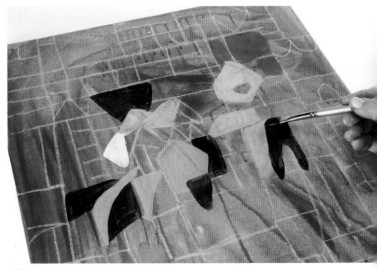

3 Block in large color shapes with the darkest version of colors.

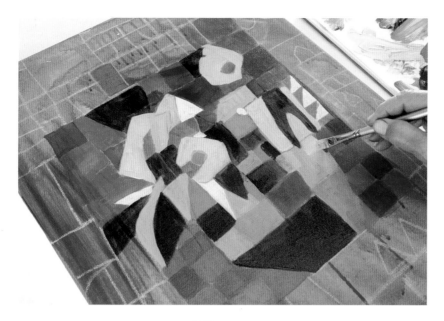

4 Mix color variations and layer thicker color mixtures onto the shapes. Cover everything on the surface with three coats of paint color.

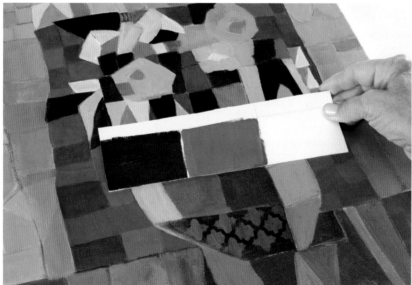

5 Step back and check your painting for value difference (light/dark contrast) using the three-value strip you created or the ValueViewer application. Adjust the values of paint colors to achieve stronger light/dark contrast.

6 Add additional pattern where desired. Here, I added a bit of a stencil pattern to the flower vase.
Apply a final finish as desired. (See Chapter 6.) I finished this painting with satin varnish.

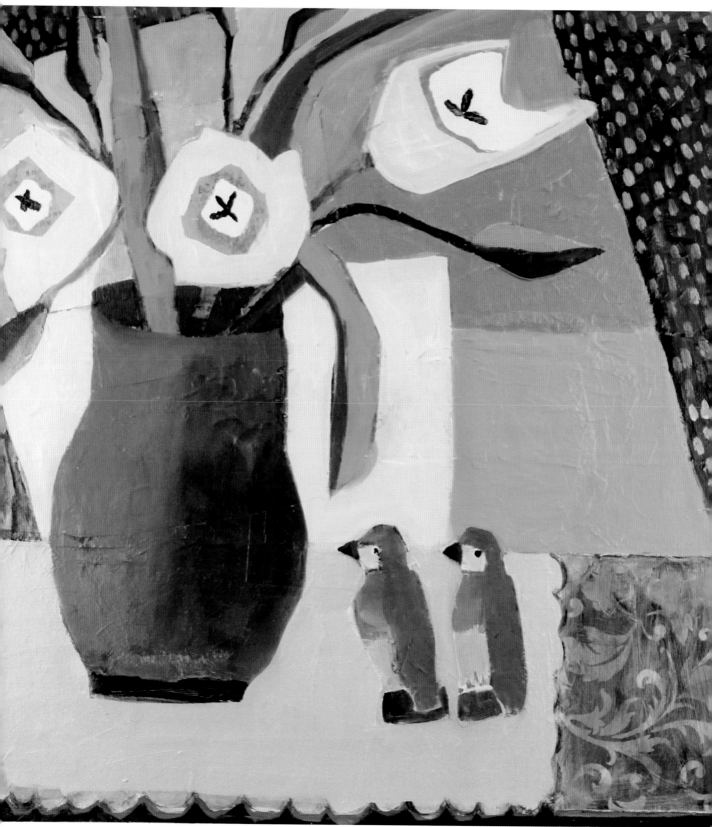

▲ TWO FOR TEA
Acrylic and mixed media on panel
18" × 18" (46cm × 46cm)

project 15: Paint a Photo-Inspired Abstraction

This project is also painted from a photo inspiration. One method of finding a new take on a common subject is to drastically change the size and scale of the object. Georgia O'Keeffe, one of my Art Ancestors, took the smallest flowers and enlarged them on her canvases so that the paintings took you inside the flower—what she called a "bee's eye view." It was a view no other painter had seen and she became a sensation for it that lives on today. Photography can help us to change the scale of objects so that they become shapes and colors. It's interesting and easy and a valuable exercise in using shape and color to create paintings abstracted from reality.

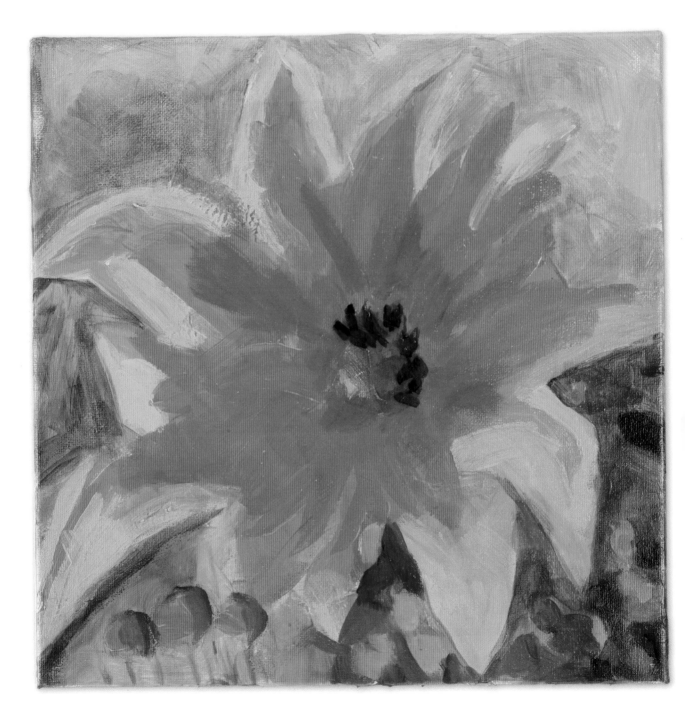

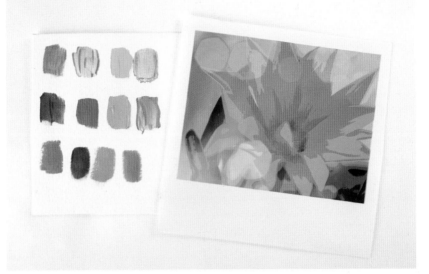

what you need

- acrylic paint, professional-grade, color scheme of your choice
- canvas or panel, your choice of size
- colored pencil or dry pastel
- paintbrushes, synthetic or bristle, bright ¼", ½", 1" (6mm, 13mm, 25mm)
- photo of subject
- smartphone, tablet or computer and photo app
- three-value strip or ValueViewer app

1 Find one of your own photos for inspiration. I chose an orange lily—one of my favorite subjects—from my smartphone camera roll. Enlarge the image on your phone, tablet or computer with your photo application so that it is so large that it becomes an abstraction of the subject. Crop the enlarged view of the subject and save as a new photo. Print the photo on a full sheet of paper or use it directly from your phone or computer for your painting reference.

Decide on a color scheme and create a swatch. I used Fluorescent Orange, Interference Gold, Quinacridone Magenta, Cadmium Red Medium, Cadmium Yellow Medium, Cadmium Yellow Light, Phthalo Blue (Green Shade) and Titanium White.

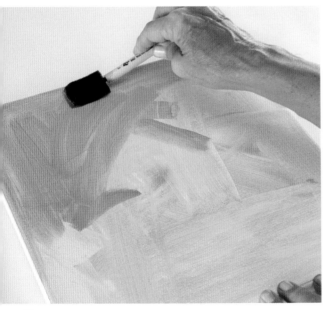

2 Underpaint your surface thinly with a color from your color scheme.

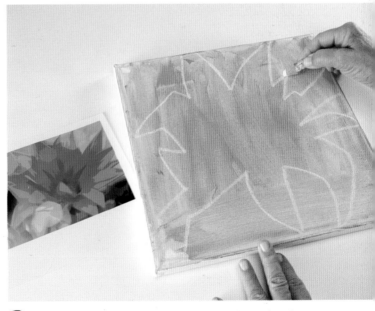

3 Sketch in the largest shapes with a colored pencil or dry pastel to create a map of your composition.

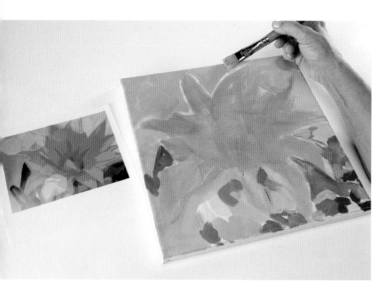

4 Block in the darkest version of colors onto the larger shapes. Mix color variations and layer thicker color mixtures onto the shapes. Cover everything on the surface with more color so that all of the surface has three coats of paint color.

5 Step back and check the painting for value difference (light/dark contrast) using the three-value strip you created or the ValueViewer application. Adjust values of paint colors to achieve stronger light/dark contrast.

Add smaller details with color variations to break up larger shapes, keeping in mind your overall color scheme and value contrast.

Add additional pattern where desired. I added a few dark accents that were in the photo to create a focal point. Allow to dry and apply final finish as desired. (See Chapter 6.) I finished this painting with satin varnish.

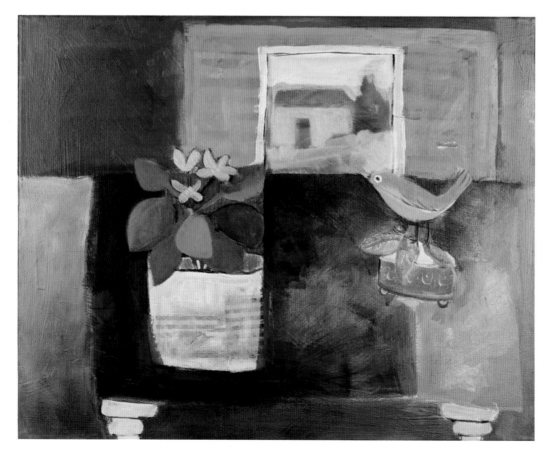

◄ **LITTLE BIRD**
Acrylic and mixed media on canvas
18" × 24" (46cm × 61cm)

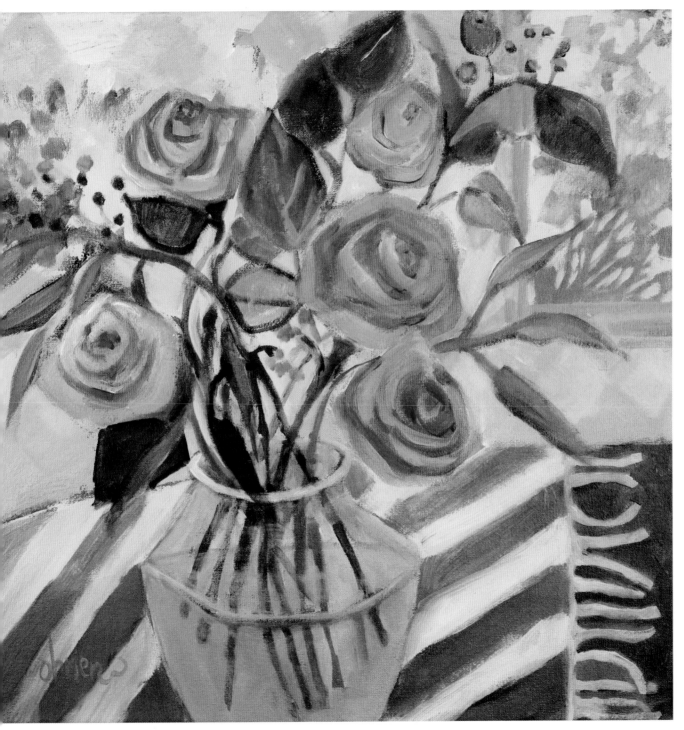

▲ **PINK ROSES**
Acrylic on canvas
18" × 18" (46cm × 46cm)

project 16: Paint an Imaginary Landscape

This is a fun project to get you thinking about how to expressively paint landscapes. The trick is to pare the landscape scene down to its component shapes and colors and still express the mood of the landscape. There is no wrong way to do this, just go with where it leads you. My inspiration was a photo I took of the beach on our Hawaiian vacation. I chose a palette of blues and greens to suggest the islands with an underpainting of complementary orange suggesting the beautiful sunsets I saw on vacation.

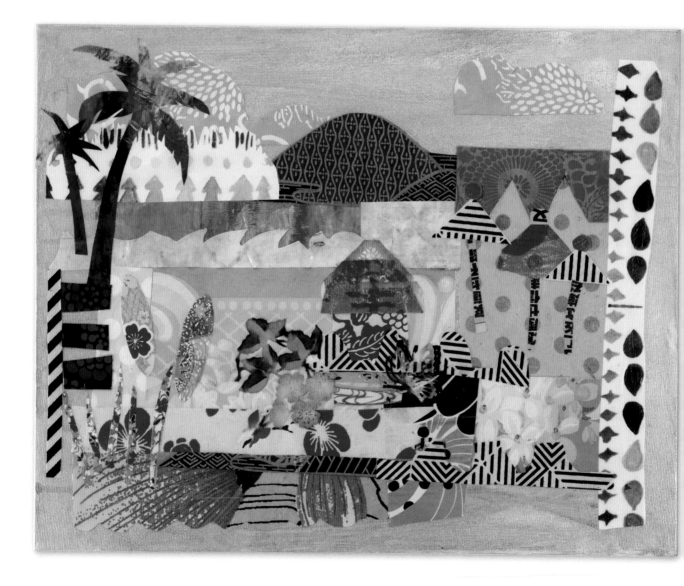

what you need

- acrylic gel medium
- acrylic paints, professional-grade, colors of your choice plus gold
- canvas or panel, rectangular, your choice of size
- collage paper, a variety
- landscape photo, your own or from a magazine
- paintbrush, inexpensive 1" (25mm) stiff synthetic
- paintbrushes, synthetic or bristle, bright ¼", ½", 1" (6mm, 13mm, 25mm)
- Painting Notes sketchbook
- pencil
- scissors
- water-soluble crayons

1 Using your own photo or a magazine landscape photo as a reference, draw a sketch with simple abstracted shapes in your Painting Notes. Remember this isn't supposed to be a realistic drawing; it is just lines and shapes.

2 Decide on your color scheme and sort collage papers into stacks according to colors. I chose a complementary color scheme of blues and greens with orange accents.

Underpaint your surface thinly with contrasting color from your color scheme. I used Fluorescent Red for a little pop of color.

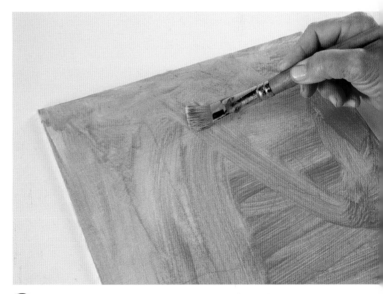

3 When the underpainting is dry, thinly apply gold paint (I used Iridescent Gold) loosely around the edges of the painting, letting some color glow through.

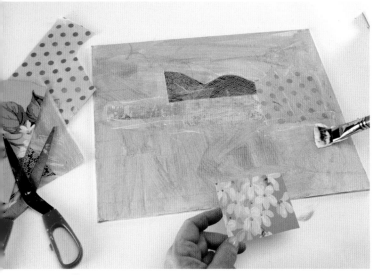

quick tip

Even though they may not be part of your color scheme, consider including some black and white patterned paper in your painting for added dramatic value and contrast.

4 Draw a basic map of large shapes onto your panel using water-soluble crayon. Don't feel like you have to follow the sketch or the photo exactly; feel free to improvise shapes or leave out details.

Using your drawn shapes as a visual reference, cut large shapes from your papers, choosing different patterns and colors within your chosen scheme to begin blocking in the composition. I used analogous blues and greens.

Using an inexpensive brush and acrylic gel medium, begin gluing down these larger shapes. Smooth bubbles out with your hand or brayer and allow to dry.

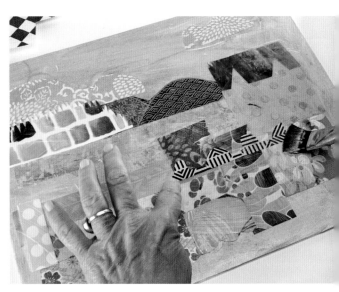

5 Using contrasting patterns, colors and values, cut out smaller details to break up the larger shapes and glue these down.

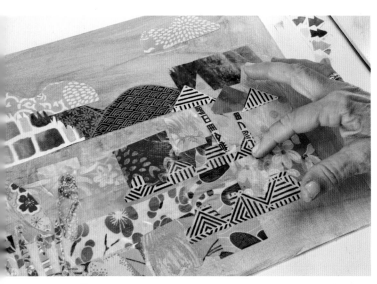

6 Step back and take a look at your composition. Decide if more collage is needed to break up larger shapes or create greater contrast. Add whatever might be needed.

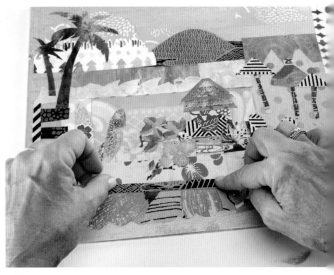

7 Add final details such as those in the foreground. Apply final finish as desired. (See Chapter 6.) I finished this painting with Golden Self-Leveling Gel.

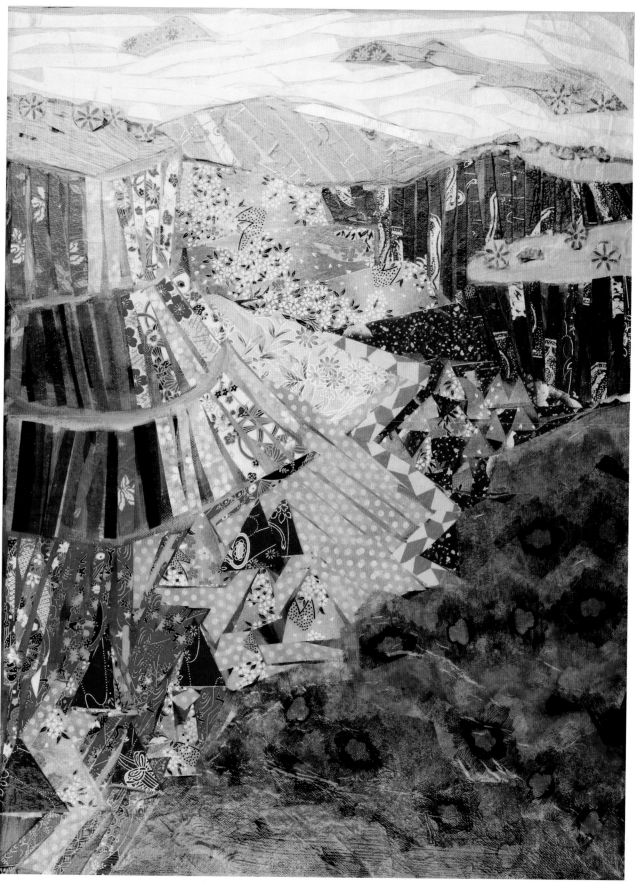

▲ **RIO GRANDE**
Acrylic and mixed media on canvas
24" × 20" (61cm × 51cm)

project 17: Paint a Layered Abstraction

When wandering through museums or galleries, you will frequently hear comments like "my kid could do that" about abstract paintings. The truth is that abstraction is actually the most difficult to do well. True abstract painting has no reference to real objects; it is a thing unto itself composed strictly with only the Elements of Art and the Principles of Design as a guide. Abstract paintings differ from *abstracted* paintings in that they are derived from a visual inspiration, such as a landscape or flowers, and are what most expressive painters pursue. But don't let this discourage you; it is definitely a great learning experience to paint abstractly and worth pursuing especially if this is the style of expressive painting that really makes your heart sing. This project will test your knowledge of the Elements of Art and the Principles of Design, so you might want to jump over to Chapter 3 for a quick review before you start. It's a lot of fun for any painters who want to really stretch themselves and teaches you to think in terms of the Elements and Principles instead of only subject matter.

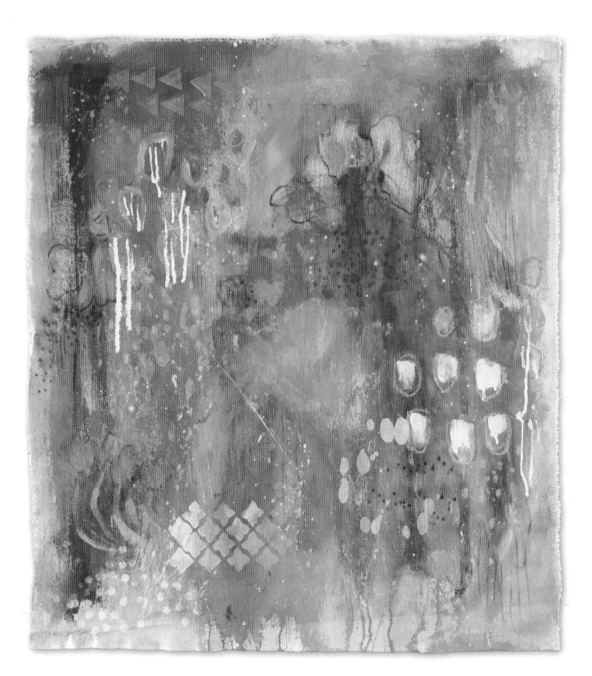

what you need

- acrylic paints, professional-grade, in color scheme of your choice
- canvas, unstretched, 30" × 30" (76cm × 76cm) or larger
- mark-making tools, your choice (I used Faber-Castell Gelatos, Stabilo Woodies, dry pastels, Neocolor crayons, Liquitex acrylic paint markers)
- paintbrushes, synthetic or bristle, bright ¼", ½", 1" (6mm, 13mm, 25mm)
- spray bottle for water
- stencils, stamps, masks, your choice
- wall space or panel to tape or tack loose canvas

quick tip

Leaving a canvas taped up like this, long term, is a great place to throw leftover paint at the end of each day, adding to it until it feels full and complete. If you practice this technique enough, you will have a nice stack of painted canvases that are much easier to store than large stretched canvases. These loose canvases can be stretched for paintings, but they also make great pillows, tablecloths and wall hangings. I use them as table runners—pretty artsy and no one has one like them!

1 Create your color scheme swatch. Tear or cut loose canvas into a large shape and tape or tack it to a wall or a panel leaning against a wall in an area where paint won't harm the surroundings.

Turn on your favorite music and begin by making loose random marks with paints, crayons and markers.

Draw icons from your Painting Notes sketches with pencils or crayons; I used variations on tulip shapes.

Splash paint onto the canvas by scooping a larger blob and applying it randomly all over. Periodically spray the surface with water to create drips and unexpected mixtures of colors.

2 Block in some larger color shapes; go back and forth between large and small tools and brushes to create different kinds of marks.

Throw a little paint; it will feel great!

Keep layering paint and marks so the surface develops some character. Don't stop at this point to evaluate or make judgments; remember anything can be covered over in acrylic. It's one of the beautiful things about it!

When you reach a stopping point (maybe the music ends?), step back and check for difference in values (light/dark contrast), shapes (large/small) and line quality (thin/thick). Remember the elements: line, shape, color, value and texture.

Add some smaller shapes to break up large shapes; don't think too much, just do it.

Play around with a variety of techniques such as those illustrated here.

Towards the end you can add marks with oil sticks. Remember that oil has to be placed on top of acrylic not the other way around.

Spend only about thirty minutes on this project. Work quickly before you have time to second-guess yourself. You might want to put this one aside and start another.

This is how you create an abstract series. This is supposed to be fun and should not be stressful; in fact, do this when you need to de-stress and loosen up.

Techniques to Play With

With the exception of using oil sticks, which should be used last if you decide to use them, these techniques can be layered and applied in any order.

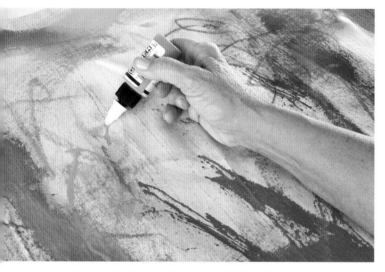

Draw with the applicator tip of fluid acrylics.

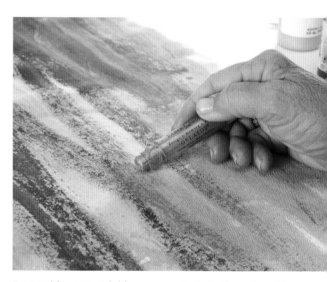

Draw with water-soluble crayons. Activate the color with water or leave it as it is.

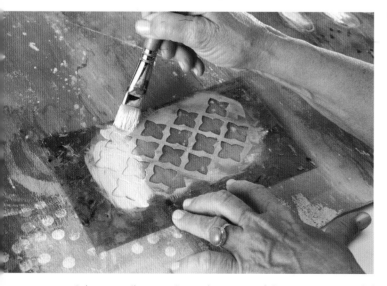

Select stencils to use in random areas of the canvas. Use with heavy-body paint for the best results. You don't need to use the entire stencil, nor do your strokes need to be perfect.

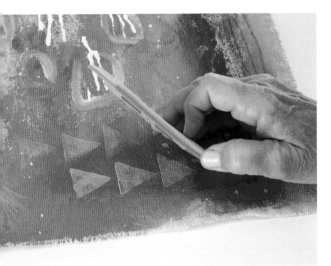

Stamp with paint, using the craft foam stamps you made previously.

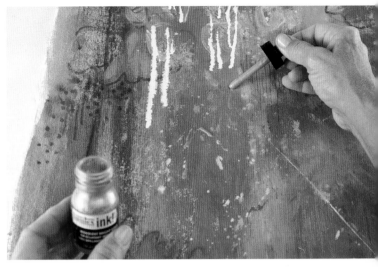

Use the dropper from the lid of inks to drip, draw or spatter ink in places.

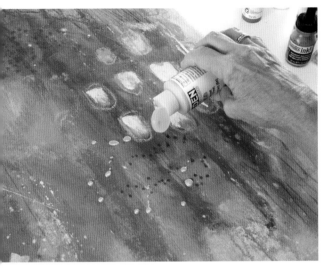

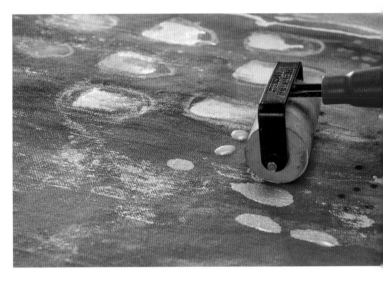

Create drips from larger bottles of fluid paint and then flatten the drips with a brayer.

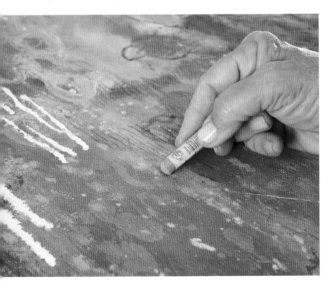

Draw with oil sticks or oil pastels for final details or pops of color.

project 18: Monoprinting with Paint and Stencils

What can I say about Gelli plate monoprinting? It is just genius and so much fun! You must try Gelli monoprinting; I can't emphasize this enough. You can employ it as a wonderful technique for creating tons of collage paper or creating finished works of art. It is so easy to learn yet has so much possibility. I recommend you make a day of it every now and then because once you get started it is hard to stop, and it seems to generate ideas the more you do it. You will notice I used mostly fluid acrylic paint, but you can use heavy-body paints as well; just experiment to see what works best for you. Here are a couple of simple ways to get started. There's a lot more information on the gelliarts.com website, in books and online. Have fun with this!

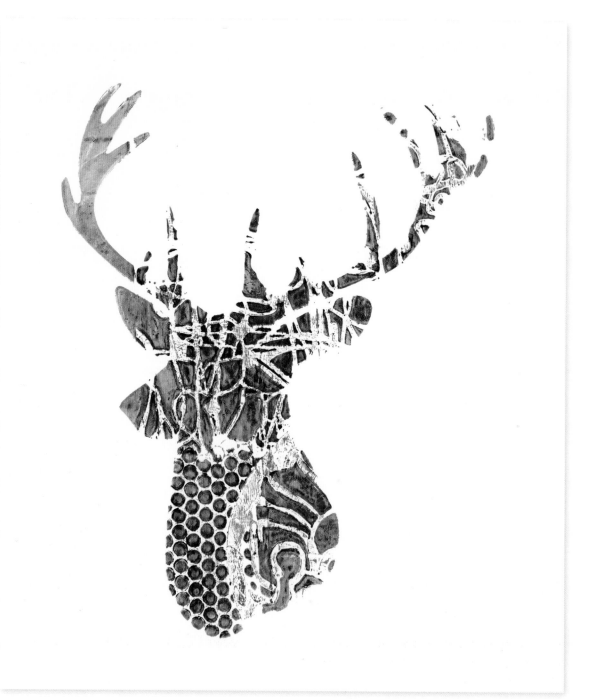

Option 1: Printing with a Stenciled Image

what you need

- acrylic paints, fluid, color scheme of your choice
- brayers, 2
- deli paper or newsprint
- Gelli Arts Gel Printing Plate
- stencils, assortment

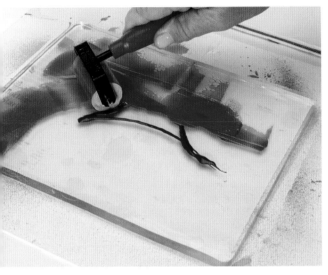

1 Squeeze a small amount of acrylic paint onto the Gelli plate and spread it thinly with a brayer to cover the plate.

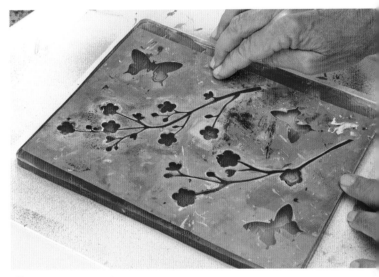

2 Lay a stencil on the Gelli plate.

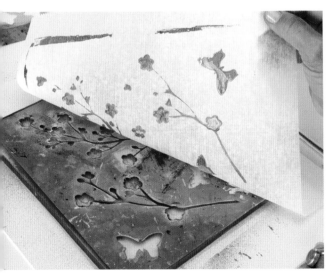

3 Lay deli paper or newsprint on the plate, smooth it thoroughly with your hand or a clean brayer, and gently pull the first print up from the plate.

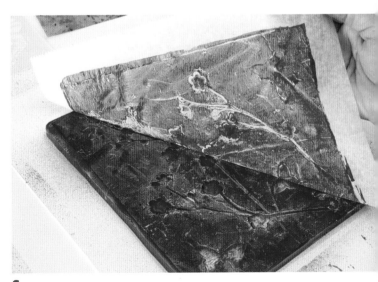

4 Apply more paint over the stencil and pull a new print.

Option 2: Printing with Multiple Stencils

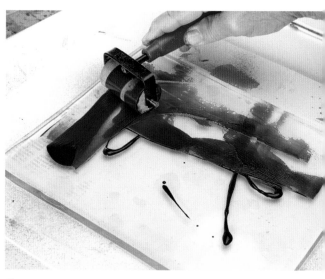

1 Squeeze a small amount of fluid acrylic paint onto the Gelli plate and spread it thinly with a brayer to cover the plate.

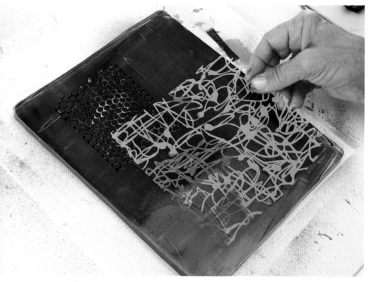

2 Lay stencils on the plate.

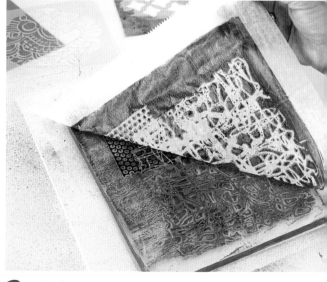

3 Pull a first print on thin paper. A thin layer of paint should remain on the plate.

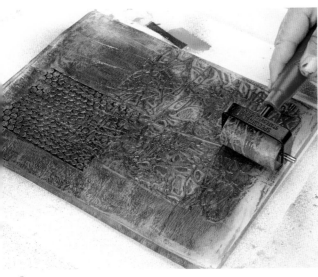

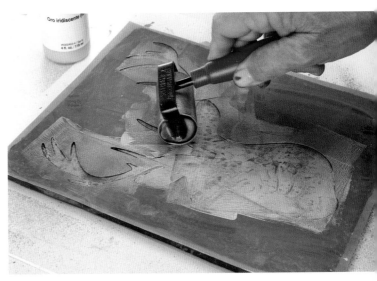

4 Using a brayer, apply a second color over the stencils and the plate.

5 Remove stencils gently off the plate and set a stencil of a large image—such as a deer head—onto the plate. Apply more color using a brayer.

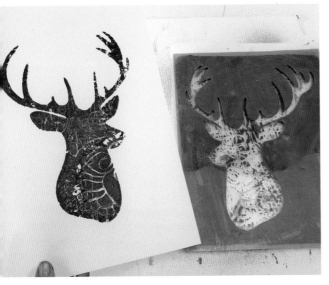

6 Pull a print using a clean piece of paper.

quick tip

For the processes here that use watercolor paper, use at least 140-lb. (300gsm) weight paper to prevent buckling. Watercolor paper can be expensive, so I suggest starting with inexpensive pads of paper for experimentation. You can always graduate to higher-quality paper when you perfect your technique. Keep trying these until you get something you love. You can use the ones you don't fall in love with as underpaintings and print over them.

7 Remove the stencil from the plate. Apply a clean piece of paper to the plate and pull a second print. Clean your plate and stencils with baby wipes.

▲ **HIDDEN GARDEN**
Mixed-media collage on watercolor paper
15" × 11" (38cm × 28cm)

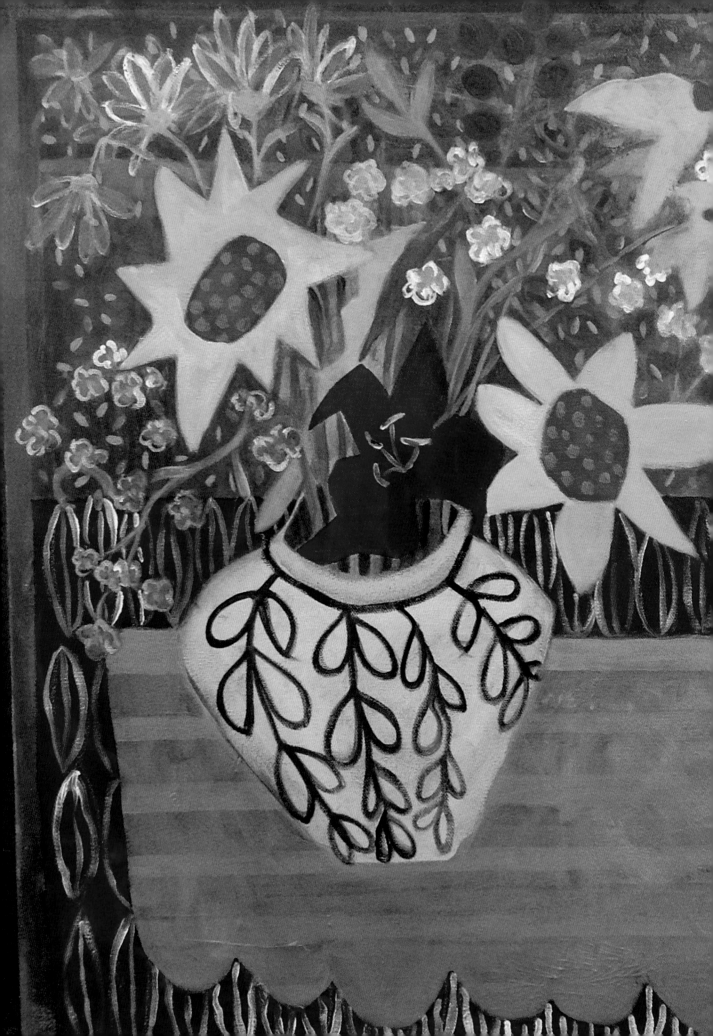

fixing and finishing your work

*Great things are done by a series of small things
brought together.*

—VINCENT VAN GOGH

An important element of learning to paint is
critiquing your own work and understanding the
application of final finishes. This chapter outlines
a framework for critiquing your work and
identifying areas that need more work, a couple
of handy techniques for enhancing your work
that you might want to try, and three methods
of finishing your paintings to add that extra
professional touch.

◄ **SUMMER SUNFLOWERS**
Acrylic and mixed media on canvas
24" × 24" (61cm × 61cm)

technique 8: Critique Your Work

Consistently critiquing your own work ensures that you are improving with each painting and moves you another step closer to your painting goals. Systematically critiquing yourself within a framework allows you to make adjustments in your current piece and learn something you can carry to the next one. Copy and print out both sets of the following Critique Criteria and post them in your work space to help you to critique your own work.

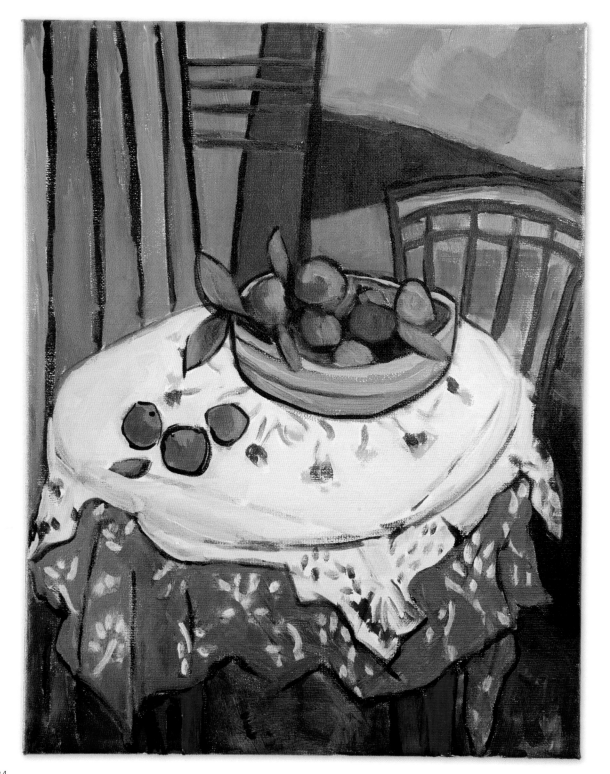

what you need

- Critique Criteria (Elements of Art and Principles of Design checklists)
- Painting Notes sketchbook
- painting to critique
- pen

Critique Criteria: Elements of Art Checklist

	common problem	questions to troubleshoot
LINES	Lines lead eye off the picture plane	Are lines a key element in the painting, or are they adding or distracting from it? Would more emphasis on line enhance the painting?
SHAPES	Equal size, distribution and/or intervals creating boring composition	Are sizes of shapes varied and an uneven number? Are the spaces between shapes varied?
TEXTURE	Too smooth or distractingly busy	Is texture a key element in the painting? Is texture (visual or tactile) enhancing the look of the painting?
VALUE	Predominantly middle values adding up to a boring painting	Have the values skewed to a middle gray with little value contrast? Could greater contrast in values enhance the painting?
COLOR	Incoherent carnival of colors without color scheme	Is color a key element in the painting? Did I stick to my color scheme? Do color choices relate well to each other?

Critique Criteria: Principles of Design Checklist

	common problem	*questions to troubleshoot*
UNITY	Looks like it was painted by several people	Do the elements work in harmony to create a whole?
PATTERN	Looks arbitrary or overdone	Do the symbols in the design work? Would more or less pattern be better?
RHYTHM	Lacks rhythm	Does the painting have a rhythm to it?
MOVEMENT	Static or claustrophobic	Does the composition lead your eye through the painting?
BALANCE	Unbalanced	Does the composition convey a sense of equilibrium or does it feel off balance?
SCALE	Scale appears odd	Is the scale of objects in the painting working?
EMPHASIS	Emphasis distracted by unintended glitch	Where is the emphasis in the painting? Is that what you intended?

In-Process Critique

1. Hang the painting on the wall or the easel, walk across the room, turn around and pay attention to your first response.
 - Start with the positive: Find something you love in the work.
 - What's the best part?
 - Where does your eye go first?
 - Does something grab your eye? Is that what you intended or is it something you can fix?
2. Take a smartphone photo of the painting. Obvious composition problems may jump out in the photo.
3. Try looking at the photo in black-and-white mode on your phone or with the ValueViewer application or squint your eyes to check for strong value contrast.
4. If you suspect composition is an issue:
 - Use a mirror to look at the painting in reverse.
 - View the painting upside down.
5. If you suspect color is an issue, take the painting outside to view it in the daylight before changing it.
6. Correct any of these obvious concerns, set it aside and do a final critique at a later time.

Final Critique

7. Put the painting away and come back the next day or next week to take a critical final look.
8. Use the Elements of Art and Design Principles to do a final critique of your painting before adding a final finish.
9. Make notes in your Painting Notes about the key elements you used in this painting and the areas you would like to improve in the next one.

critiquing the work of others

- Always find something positive to comment on before launching into problems. Example: What did the artist communicate well?
- Be honest but not brutal.
- Suggest solutions to problems.

when others critique your work

- Take the risk and bring the work you have the most questions about.
- Listen to the critique with an open heart and mind.
- Try to remain objective and momentarily pretend you are not the artist.
- Try to stay quiet except for asking for clarification.
- Jot down solution ideas and decide for yourself if you want to use them.

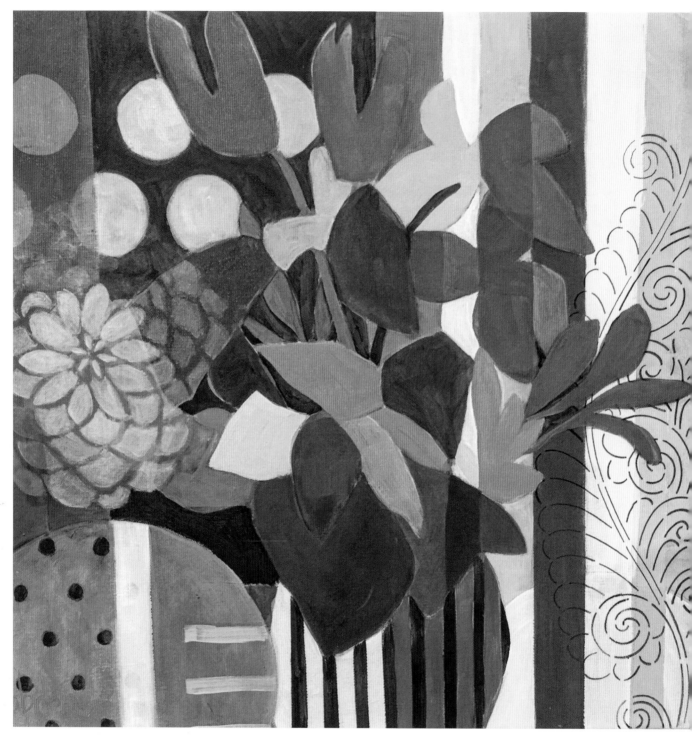

▲ **TULIP GEOMETRY**
Acrylic on canvas
24" × 24" (61cm × 61cm)

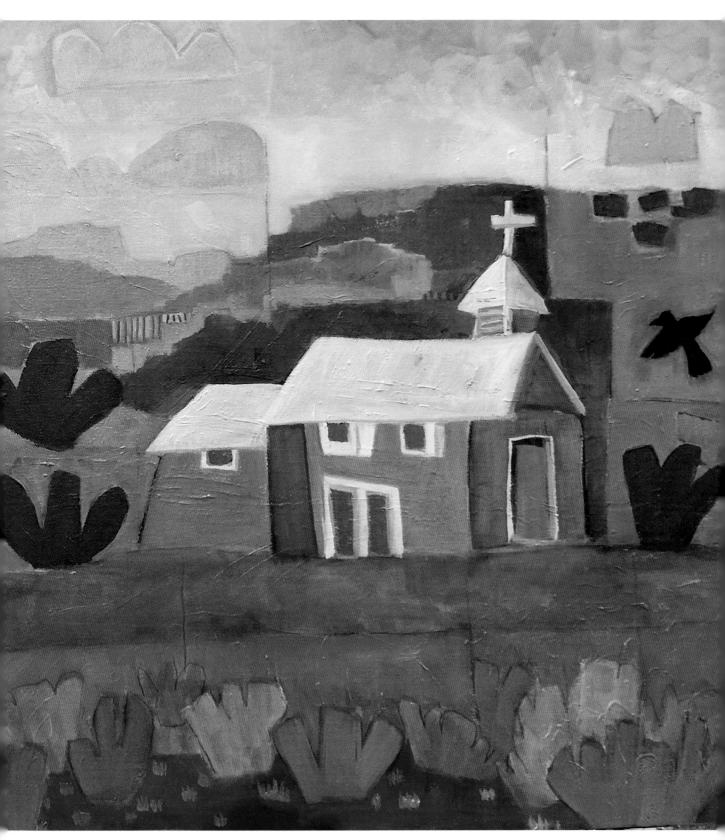

▲ OH NEW MEXICO!
Acrylic on canvas
18" × 18" (46cm × 46cm)

technique 9: Fix a Problem Painting

When you finish a painting and do the In-Process Critique, you will probably want to make a few corrections. Here are a couple of techniques you might use to fix a painting that just isn't working. You may want to practice these methods on paintings you consider a disaster until you are comfort- able with the techniques. Keep these options in mind and use them as needed. Never be afraid to try something new; taking a chance is how you will make your work unique and personal.

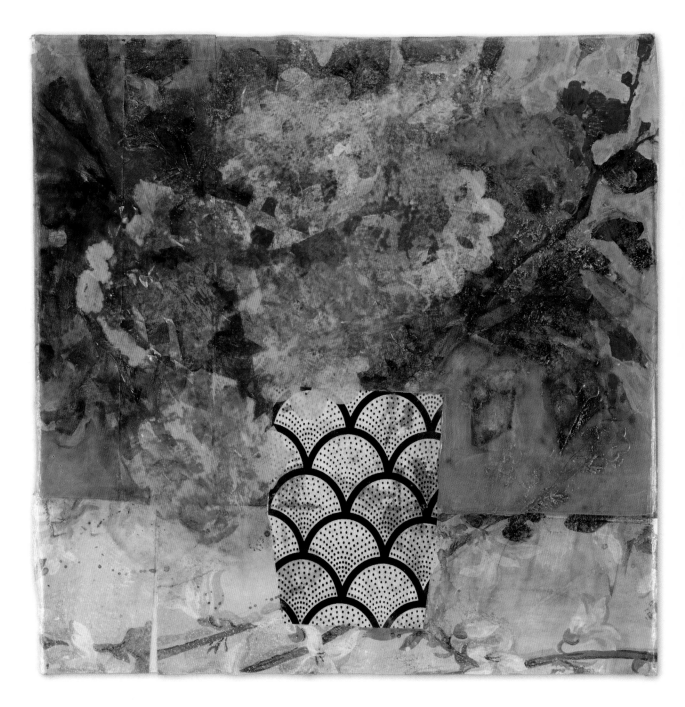

Negative Painting

This mixed-media collage painting lacked value difference between the foreground and the background and was somewhat jumbled and chaotic. I decided to try negative shape painting around the central image to make it pop and calm it down a bit.

what you need

- acrylic paint: mixture in a dramatically lighter or darker value and/or a complementary color from the main subject of the painting
- acrylic painting (dry) that needs more contrast
- paintbrush: 1" (25mm) bristle bright or flat shape

1 Step back and take a long look at the painting. Decide what it needs to create a dramatic shift in value and/or color between the main subject and the background. Use your three-value card or the ValueViewer app on your smartphone to determine if lack of value and contrast is the issue. A common problem is that everything has drifted towards middle value. Think about a dramatically darker or lighter background and/or shifting the color to a warmer or cooler mixture—whatever is the opposite of the main subject.

Mix the background color and check the dark/light value contrast and warm/cool color contrast by holding a brushload of the new color next to the main subject in the painting. Go for the boldest contrast here; don't hold back!

With a lot of paint on your brush, begin to cut around the main subject creating new shapes as you paint over the background.

2 Don't be afraid to be bold and carve some shapes into the edges of your subject matter with your background color. You are painting the negative shape—what is *not* the main subject but makes the subject pop forward.

Let it dry. In the unlikely event that the new background color doesn't work, try again and paint over it. You have nothing to lose and everything to gain by taking chances.

Glazing

Glazing is a nifty technique that can really save a very blah painting. When you just can't think of what to do or you have given up on a piece, try glazing it with a transparent color to see what happens. You will be surprised by the abrupt change it creates. You can practice on paintings you have relegated to the "just not working" shelves to get a feel for glazing. Choose a painting, then decide whether it needs to lean towards cool (blue) or warm (yellow or red).

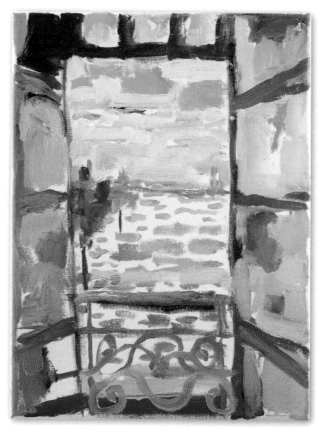

Here is my original painting that I wasn't entirely happy with.

1 Mix a drop of fluid acrylic paint into a small amount of acrylic glazing liquid in a small cup. The amount needed will depend on the size of the painting, but lean towards a smaller amount; you can always make more.

2 Apply the mixture with a soft brush across the entire canvas in one application. If the color is too intense, immediately wipe the painting with a wet cloth to lighten the glaze. Let dry.

quick tip

Some of the great fluid acrylic colors by Golden that I consider magical for their transformative properties include:

- Phthalo Turquoise
- Quinacridone Magenta
- Quinacridone Nickel Azo Gold
- Transparent Red Iron Oxide
- Transparent Yellow Iron Oxide

Be aware that it is difficult to remove a glaze after it is applied. Make sure you have a wet cloth ready to remove as much as possible before it dries if you aren't happy with the color.

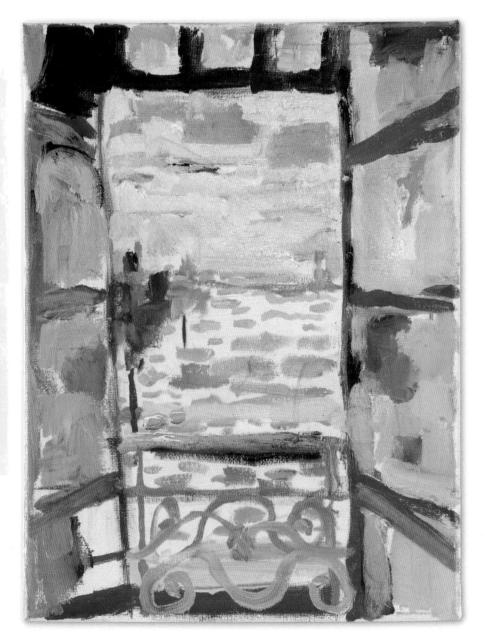

technique 10: Finish Your Painting

When you have completed a painting, there are several techniques you can use to give it a final professional finish. Three finishes I recommend on acrylic mixed-media paintings include varnishing, cold wax and acrylic self-leveling gel.

Varnish

Varnish is a traditional finish for paintings that provides a professional finished look as well as a protective layer that can be removed if needed. Varnishes come in matte, satin or gloss finishes, in liquid or spray form and will bring the colors in the painting to life. You can put several coats of varnish on your painting, allowing it to dry between coats. Follow directions on the container for different brands. Be sure to check that the varnish is suitable for acrylic paintings before applying.

what you need

- brush, soft 1" (25mm) (Make sure it does not shed brush hairs on surface.)
- paper towel or rag, damp
- small container to hold varnish mixture
- varnish for acrylic (Golden Polymer Varnish with UVLS or Liquitex Satin varnish)
- water container

1. Dilute varnish with water according to label instructions.
2. Dust painting off with a damp clean cloth, then apply smooth single strokes of varnish covering the entire painting. Be careful not to stroke too vigorously back and forth, which creates bubbles in the varnish.
3. Allow the varnish to dry in a dust-free room.

Acrylic Self-Leveling Gel

This product creates a very glossy, level surface on a painting—somewhat like the resin finish that's become very popular. The advantage of this gel is that it is less toxic and easier to apply than resin. It is especially effective with collage pieces since it levels the surface and increases clarity and shine.

what you need

- acrylic Self-Leveling Clear Gel (Golden)
- foam brush, 1 " (25mm)
- water container

quick tip

If you want to tone down the shine a bit, add a thin layer of cold wax over the surface after the self-leveling gel has dried. Wait for the cold wax to dry and buff lightly with a soft cloth. Best of both worlds!

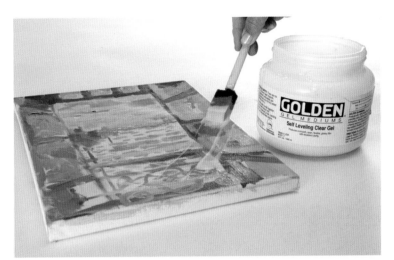

1. Pour the gel onto a completely dry painting on a flat surface.
2. Spread the gel over the painting, using a damp foam brush until all of the surface is covered.
3. Allow the gel to dry in a dust-free zone and don't worry, it will self-level and brushstrokes will not be visible when dry.

Cold Wax

Cold wax, composed of beeswax, mineral spirits and resin, adds a soft translucent sheen to paintings. Be sure you are completely finished using any acrylic paint or water-soluble products on your painting before you finish it with cold wax, since you will not be able to add these successfully over the wax. Oil-based products, however, such as an oil stick may be used over the top of a cold-wax varnished painting. Cold wax may be left to dry as a matte finish or polished with a soft cloth to an attractive luster.

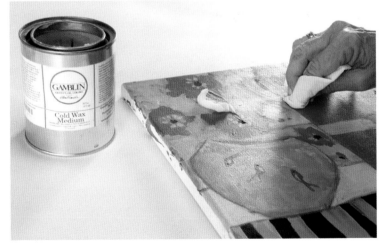

1. Apply wax thinly to the surface of your dry painting, using a soft cloth.
2. Allow to dry. (Drying times vary.)
3. If desired, polish with a soft cloth.

what you need

- cold wax
- soft rag

Final Thoughts

Remember the **heart, hand and eye** analogy from Chapter 1?

- Heart (Passion): The desire needed to prioritize learning to paint.
- Hand (Skill): Specific skills and knowledge needed to paint well.
- Eye (Vision): Unique ideas to create an individual painting style.

Painting requires development in all three areas. The only way to reach your goals in all three areas is to paint a lot—no excuses. If you are still working or raising children, you may have to acknowledge that your learning curve may be slower at this point in life but will pick up speed when you have more time. In the meanwhile, you can keep filling the well of creativity by going to museums, adding sketches and ideas to your Painting Notes, taking the occasional workshop or online class and reading a lot about art and artists. Every bit of time counts; small moments add up and lead to increased skills over time. The time will pass anyway, so you might as well be gaining ground, right?

Remember, it is *deliberate practice* that makes a difference. Target your learning and practice so you are accumulating the knowledge and skills you need. Don't waste time on classes or books that aren't relevant to where you want to go. If you are at a point in life with more time to invest in your passion for painting, good for you—go for it!

I have been there. I went to art school and then never painted for twenty years because life got in the way. I started painting full-time twelve years ago when I quit my job and realized it was now or never. I walked into my first acrylic painting class back then with my knees wobbling. One teacher told me not to evaluate any of my paintings until I had done one hundred of them. I was so determined that I actually numbered my not-so-great paintings until I got to one hundred!

Everyone has a different learning curve, but as long as you are painting and making steady progress and learning something, that's deliberate practice and that's what counts.

Things to Remember

- Focus on process not product.
- Take the "Bird-by-Bird Approach"—one step at a time!
- Paint a lot. Give yourself permission to create many, many bad paintings in order to get to the good ones. There is no other path.
- Stay positive and always tell yourself you can do this.
- Create a painting schedule and stick to it. Do not wait to paint until you feel creative.
- Go to the studio or painting space every time you have a chance and do something, anything.
- Create a ritual around painting: setting up a still life, arranging your tools and paints, brewing a cup of tea. Rituals become habits.
- Enjoy the process. The most frustrating day of painting should be the best thing you could choose to do with your time or go do something else. Life is short.

- Don't worry about creating a signature style. It will happen when you paint enough; it's like handwriting.
- Positive or negative feedback from well-meaning family members is probably not helpful—too much history.
- Accept that not everyone will love your work. Art is subjective. The only person you have to please is yourself.
- Begin to call yourself an artist; it is the first step towards believing it with your heart and soul. Never ever apologize for your work or your path, own it.
- Craft an "elevator speech" for yourself so that when a stranger asks about your work you are ready. Include:

 What your art is about—the subject, theme or idea?

 What medium you work in?

 Inspiration for your work?

 Where you see yourself going with your work?

If you follow your bliss, you put yourself on a kind of track
that has been there all the while, waiting for you
Follow your bliss and don't be afraid, and doors will open
where you didn't know they were going to be.
—JOSEPH CAMPBELL

Inspiration Resources

Books – Self-Development

Bayles, David and Ted Orland. *Art & Fear: Observations on the Perils (and Rewards) of Artmaking*. 1993.

Boyle, Prill. *Defying Gravity: A Celebration of Late-Blooming Women*. 2004.

Brown, Brené. *Rising Strong: The Reckoning. The Rumble. The Revolution*. 2015.

Cameron, Julia. *It's Never Too Late to Begin Again: Discovering Creativity and Meaning at Midlife and Beyond*. 2016.

Cameron, Julia. *The Artist's Way*. 2002.

Duckworth, Angela. *Grit: The Power of Passion and Perseverance*. 2016.

Gilbert, Elizabeth. *Big Magic*. 2015.

Kleon, Austin. *Show Your Work*. 2014.

Kleon, Austin. *Steal Like an Artist: 10 Things Nobody Told You About Being Creative*. 2012.

Krysa, Danielle. *Creative Block*. 2014.

Krysa, Danielle. *Your Inner Critic Is a Big Jerk*. 2016.

Lamott, Anne. *Bird by Bird: Some Instructions on Writing and Life*.199

Luna, Elle. *The Crossroads of Should and Must*. 2015.

Books – Painting Methods

Albert, Greg. *The Simple Secret to Better Painting*. 2003.

Brommer, Gerald. *Collage Techniques: A Guide for Artists and Illustrators*, 1994

Hockney, David. *Secret Knowledge: Rediscovering the Lost Techniques of the Old Masters*. 2006.

MacPherson, Kevin D. *Fill Your Oil Paintings with Light & Color*. 2000.

McMurry, Vicki. *Mastering Color*. 2006.

Quiller, Stephen. *Painter's Guide to Color*. 1999.

Reyner, Nancy. *Acrylic Revolution: New Tricks and Techniques for Working with the World's Most Versatile Medium*. 2007.

Sarback, Susan. *Capturing Radiant Light & Color in Oils and Soft Pastels*. 2007.

Books – Inspiration

Barry, Lynda. *Syllabus: Notes from an Accidental Professor*, 2014

Jenny, Tonia, editor. *Incite, Dreams Realized: The Best of Mixed Media*, 2013

Jenny, Tonia, editor. *Incite 2, Color Passions: The Best of Mixed Media*, 2014

Jenny, Tonia, editor. *Incite 3, The Art of Storytelling: The Best of Mixed Media*, 2015

Jenny, Tonia, editor. *Incite 4, Relax, Restore, Renew: The Best of Mixed Media*, 2016

Websites, Blogs, Videos

Artist Daily. www.artistdaily.com.

Brain Pickings and Maria Popova. www.brainpickings.org.

Catherine Kehoe. www.powersofobservation.com.

Cold Wax/Oil Painting. www.coldwaxpainting.com.

David Hockney's YouTube videos.

Elizabeth Gilbert. "Success, Failure and the Drive to Keep Creating." TED Talk, February 2009. www.ted.com.

Gelli Arts. www.gelliarts.com.

New York Public Library Picture Collection Online. www.digital.nypl.org/mmpco/.

Smithsonian Institution Flickr Commons Photostream. www.flickr.com/photos/smithsonian.

Smartphone Applications

Colourlovers.com

Pikazo

Pinterest.com

Prisma

ValueViewer, *PleinAir* magazine

▲ **Bowl-o-Matic**
Acrylic on canvas
30" × 40" (76cm × 102cm)

Index

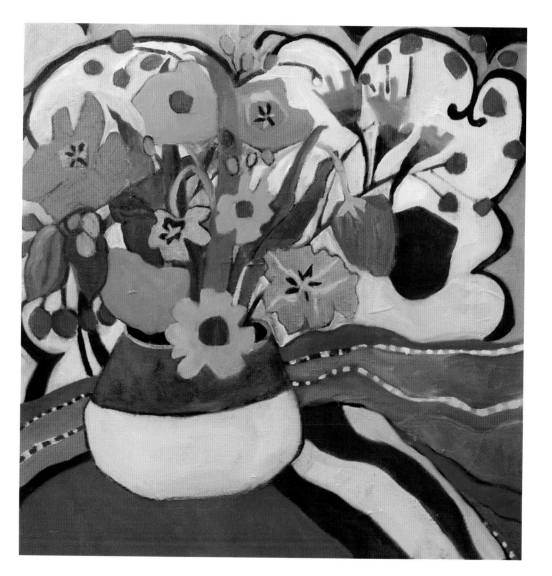

PURE JOY
Acrylic on canvas
24" × 24" (61cm × 61cm)

Other fine North Light Books are available from your favorite bookstore, art supply store or online supplier. Visit our website at fwmedia.com.

fw

a content + ecommerce company

21 20 19 18 17 5 4 3 2 1

Distributed in Canada by Fraser Direct
100 Armstrong Avenue
Georgetown, ON, Canada L7G 5S4
Tel: (905) 877-4411

Distributed in the U.K. and Europe
by F&W Media International LTD
Pynes Hill Court, Pynes Hill, Rydon Lane, Exeter, EX2 5AZ,
United Kingdom
Tel: (+44) 1392 797680,
Email: enquiries@fwmedia.com

ISBN 13: 978-1-4403-5121-1

Edited by Tonia Jenny
Production edited by Amy Jones and Jennifer Zellner
Designed by Clare Finney
Production coordinated by Jennifer Bass
Photography by Kristi Johnson and Christine Polomsky

Dedication

This book is dedicated to my husband, Tom; my children, Trevor and Brooke; and my grandchildren, Milla and Jack—truly the loves of my life!

Acknowledgments

Thanks to everyone at F+W Media, they are a special group of people. A very special thank-you to Tonia Jenny for her support and encouragement and to the on-site team in Ohio—Beth Erikson and Christine Polomsky who make everything go smoothly. Thanks again to Kristi Johnson of Kristi Johnson Photography for taking beautiful shots of my studio and paintings.

metric conversion chart

To convert	to	multiply by
Inches	Centimeters	2.54
Centimeters	Inches	0.4
Feet	Centimeters	30.5
Centimeters	Feet	0.03
Yards	Meters	0.9
Meters	Yards	1.1

About Annie

Annie O'Brien Gonzales is a professional painter, teacher and writer in Santa Fe, New Mexico. In her studio on Canyon Road, she paints colorful and expressive floral, still-life and landscape paintings. She paints intuitively with inspiration from nature combined with personal symbols and pattern.

Her work is represented in galleries across the U.S. and has been shown in numerous juried art shows, collected by art lovers across the U.S. and recently was included in a museum's permanent collection. She is also a docent at the Georgia O'Keeffe Museum and a tour guide at Ghost Ranch in Abiquiú, New Mexico. She teaches private lessons in her studio in Santa Fe and workshops across the country as well as at Ghost Ranch and the Georgia O'Keeffe Museum.

Learn more about Annie at annieobriengonzales.com and follow her on Instagram @annieobriengonzales.

Ideas. Instruction. Inspiration.

Receive FREE downloadable bonus materials when you sign up for our free newsletter at ArtistsNetwork.com.

Find the latest issues of *Cloth Paper Scissors* on newsstands, or visit shop.clothpaperscissors.com.

These and other fine North Light products are available at your favorite art & craft retailer, bookstore or online supplier. Visit our websites at artistsnetwork.com and artistsnetwork.tv.

Follow North Light Books for the latest news, free wallpapers, free demos and chances to win FREE BOOKS!

Get your art in print!

Visit artistsnetwork.com/category/competitions for up-to-date information on AcrylicWorks and other North Light competitions.